Inside Information

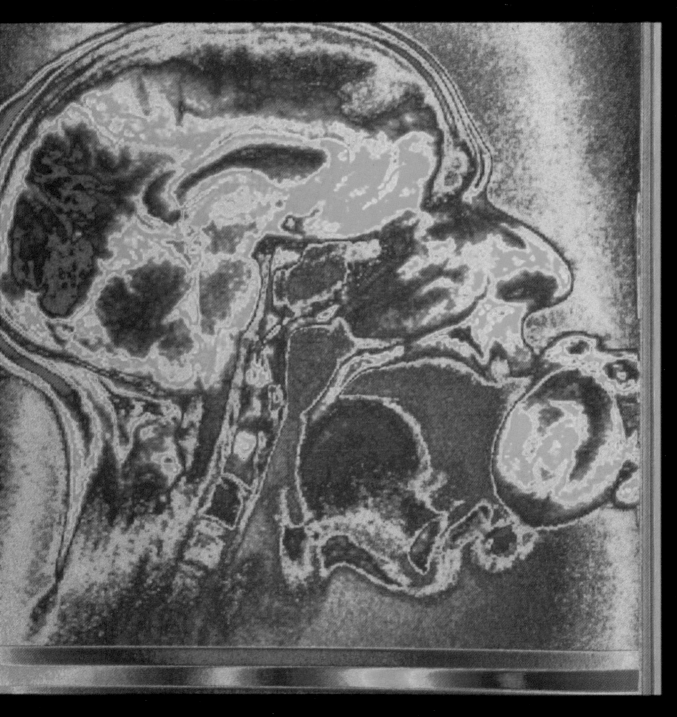

For Flora

Note to the reader: The magnifications given are approximate.

The author wishes to thank the many photographers and scientists who participated in this venture, as well as the staff of the Wellcome Institute for the History of Medicine, London, and the Science Photo Library, London, for their combined efforts in making this book a reality.

Additional acknowledgments appear on p. 127

On the half-title: The head of a man eating a plum, seen in section. Colored magnetic resonance image. Alexander Tsiaras.

FIRESIDE
Simon & Schuster Inc.
Rockefeller Center
1230 Avenue of the Americas
New York, New York 10020

Designed and typeset by Thames and Hudson
Printed in Singapore by C.S. Graphics

10 9 8 7 6 5 4 3 2 1

Library of Congress Cataloging-in-Publication Data

Ewing, William A.
 Inside information : imaging the human body / William A. Ewing.
 p. cm.
 "A Fireside Book."
 ISBN 0-684-83108-2 (pbk. : alk. paper)
 1. Human anatomy—Atlases. 2. Radiography, Medical—Atlases.
3. Diagnostic imaging—Atlases. I. Title.
QM25.E78 1997
611'.0022'2—dc20 96-13228
 CIP

CONTENTS

THE HEART, showing the veins and arteries
which supply blood to the cardiac muscles

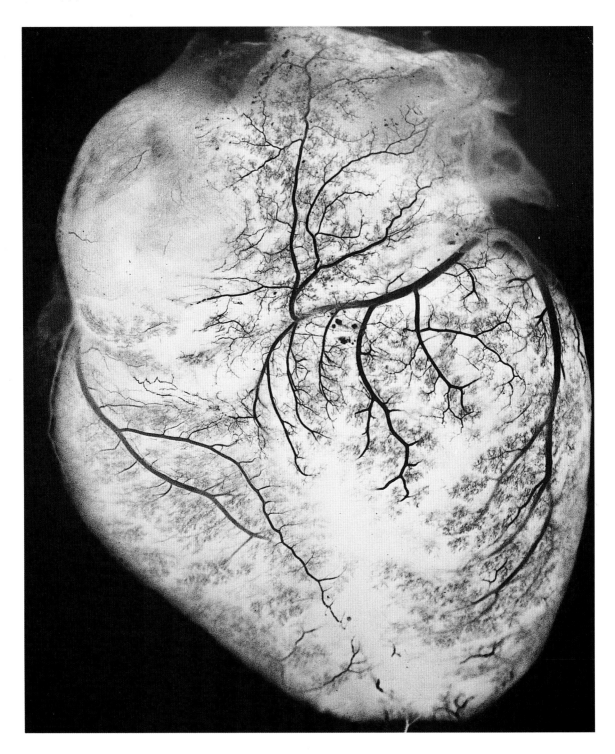

INTRODUCTION

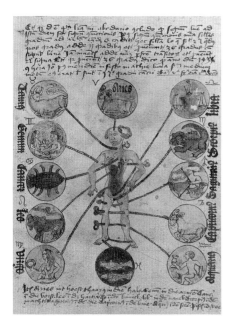

A 15th-century 'Astrological Man', with zodiacal signs. From *Heymandus de Veteri Busco, Ars computistica*, 1488

Écorché figures attributed to the circle of Bartolomeo Passarotti, Bologna, mid-16th century

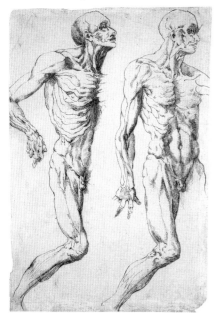

When Andreas Vesalius, the great anatomist of the Italian Renaissance, broke with medieval tradition and taboo by systematically dissecting the human body, peeling back its skin and successive layers of flesh to reveal the essence of the *corporis fabrica*, he set in motion a train of discoveries and inventions which would culminate 450 years later in the marvellous imagery to be found on the pages of this book.

Vesalius would have been astounded at the sight of this spectacular interior cosmos, for which nothing in his experience could have prepared him. He would equally have been amazed to discover that these wonders had not been revealed by the surgeon's scalpel but by superhuman, though man-made, eyes – eyes so powerful that they could actually scrutinize individual cells, their nuclei, and even single atoms. Just as astonishing, some of these disembodied eyes could probe the body's innermost secrets while it was alive and in good health without so much as physically touching it, let alone penetrating its surface.

Today, with the array of scientifically derived knowledge of the body available to us, it is still difficult to believe that these fascinating pictures are not out-takes from some popular science-fiction film like *Fantastic Voyage*, in which a team of downsized human beings pilot their minute craft on a perilous mission through the human body, but are instead the fruits of painstaking scientific investigation coupled with ingenious technology.

For all their 'hi-tech' aura, however, they are in one fundamental way a continuation of a long and venerable tradition dating back to the Renaissance: that of picturing the body and its parts precisely and accurately with the use of naturalistic techniques.

Before the Renaissance, which saw the first of this new style of representation, depictions of the body had done little to elucidate its structures and functions. During the Middle Ages, dissection was forbidden, and priests and physicians turned to the zodiac to illuminate the mysteries of the body's interior.

During the Renaissance, however, certain artists began dissecting corpses in their own studios in the belief that a proper understanding of human anatomy was essential if the exterior of the body were to be correctly depicted. In their knowledge of the body they were often in *advance* of the physicians, who were still dissecting animals and relying unquestioningly on the received wisdom of ancient texts. The accuracy of the new naturalistic techniques would prove so useful to medical men and scientists that it would eventually win over all but the most stubborn of their fellows.

From the beginning of the sixteenth century, with the growing power of the printing press, illustration played an ever more important role in communicating information about the body. Artists and scientists, along with their publishers, were constantly thinking up inventive ways of presenting their findings. The plates in Vesalius' great text *De humani corporis fabrica* (1543), for example, were so designed as to enable the reader to follow the dissection procedure step-by-step, with each of the plates revealing a deeper level right down to the skeleton. Another ingenious device of the period was an instructional sheet which had superimposed flaps that could be folded back to reveal the internal organs.

Over the following centuries the inner terrain of the body was mapped and charted. Yet there seemed no end to the finer and finer structures the probing revealed. In this

Colour mezzotint plate of an écorché human torso by J.F. Gautier d'Agoty from his *Anatomie générales des viscères en situation...*, Paris, 1752

The sophisticated French technique of aquatint allowed for reproductions of delicate washes. Plate depicting the brain from Félix Vicq d'Azyr's *Traite d'anatomie et de physiologie*, Paris, 1786

the compound microscope, an early seventeenth-century invention, proved an almost miraculous tool. The first microscopes were fairly crude, and they would remain so for a hundred years. But improvements rapidly gave scientists an indispensable tool. Today, almost four centuries after its introduction, and as a consequence of continual refinement, the microscope has evolved to the point where its resolving power (its capacity to differentiate two objects) has reached the theoretical limit set by the wavelength of light itself.

Meanwhile, through the centuries, refinements in printing techniques were keeping pace with scientific discoveries. In the sixteenth century the primitive woodcut gave way to the far more subtle techniques of engraving, etching and drypoint. Mezzotint, invented in the following century, allowed for even finer rendition of textures and tonal values, and aquatint, a century later still, made effortless the reproduction of delicate, wash-like tones such as watercolour. Late in the eighteenth century lithography joined the panoply of reproduction techniques: because it was quick, cheap and easy to use, it soon displaced traditional methods. But physicians and scientists were still able to choose which of these media best suited their requirements.

The problem of colour reproduction was also satisfactorily resolved over the passage of years. Early in the seventeenth century the tradition of hand-colouring was replaced by colour printing methods, though it was not until the first quarter of the eighteenth century that versatile three- and four-plate colour printing was introduced.

All drawings of the body had one instrument in common: the hand. And the hand was guided by the mind, as every artist and scientist knew, and therefore prone to human error. A quantum leap in the direction of verisimilitude was represented by a mid-nineteenth-century invention which promised to do away with this unreliable human instrument: photography. With light itself tracing the image, it seemed to propose a new standard of objective scrutiny. Coupled to various photomechanical reproductive processes, it became the chief medium for illustration, outpacing the dominant technique of the time, lithography.

The invention of photography coincided with the rise of cell theory, and microscopists were quick to grasp the advantages of the new medium. In France, as early as 1839, Alfred Donné, an eminent microscopist (and the discoverer of blood platelets), used '*un microscope-daguerreotype*' to record tissue and fluid samples such as human blood and breast milk. The atlas he produced with his partner Léon Foucault in 1845, the first of its kind, was illustrated by gravure copies of their daguerreotypes. In England, meanwhile, William Henry Fox Talbot, inventor of the positive/negative process of photography, spoke enthusiastically of the role photomicrography would undoubtedly play in the new science of bacteriology.

In these early years photomicrography was not without its problems. It required lengthy time exposures, its images were monochrome, its chemistry was uncertain, and its plates were insensitive to certain colours. For example, the reddish brown colour of many tissue samples would be registered on the daguerreotype plate merely as black blobs. Daguerreotypes could be used with difficulty, but calotypes – Talbot's indistinct paper prints – were impossible. But with time these obstacles were overcome, and by the mid-1860s the achievements of the photomicrographers were public knowledge. In January 1865, London's *Evening Standard* concluded: 'Allied with chemistry and the microscope, photography seems destined to give us what we might almost style a new sense – certainly a second sight.'

Rouleaux of blood corpuscles. A
daguerreotype photograph by Léon Foucault
and Alfred Donné, 1844

Meanwhile, physicians and scientists were considering other ways in which photography could be used to illuminate the workings of the human body. Some medical men focused on its surfaces, recording skin ailments, injuries and deformities. Other investigators used the camera to record facial expressions, physiognomy, racial variations, body types and bodies in motion. Still others strove to penetrate its interior with the camera. In 1862 an endoscope was used to photograph the larynx. In 1865 the retina of the eye was photographed. And in 1898 German scientists succeeded in photographing the interior of the stomach of a living person.

In the last decade of the nineteenth century an almost magical invention – a chance discovery, in fact – stole the limelight from the various photographic techniques of imaging the body's interior. With 'X-rays', as their discoverer Wilhelm Konrad Röntgen called them, it would henceforth be possible to peer inside any living human body without so much as touching it, let alone opening it up for inspection.

A less glamorous, but equally momentous event of the same year (1895) was the discovery of the electron by the Englishman J. J. Thomson. This would make possible in the following decades a potent new tool by which the fabric of the human body could be examined as never before: the electron microscope. Thomson's and Röntgen's discoveries, coupled with those of Antoine Becquerel (radioactivity) and Pieter Zeeman (the use of magnetic fields to split spectral lines of light) were two of the four major discoveries which laid the foundations for modern biological imaging systems.

In the twentieth century, scientific imaging of the body has progressed dramatically, with developments in micrography (both light micrography and electron micrography) allowing the body to be observed in ever smaller parts, and developments in diverse non-microscopic scanning techniques which allow for the depiction of physiological processes as well as morphological and anatomical structures. To list a few milestones: in 1921, X-ray tomography of living subjects was introduced (see definitions below). Five years later the invention of grainless film emulsion allowed for photomicrographs of 1/1000 life-size. In 1927 the Portuguese neurologist Egas Moniz developed cerebral angiography, which relied on an ingested contrast agent to capture on film the distribution of the brain's blood and other fluids. In 1931, the transmission electron microscope was invented, followed four years later by the scanning electron microscope. Even by themselves, these achievements in electronic microscopy heralded a new frontier of corporeal knowledge. No longer was the image maker dependent on the 'grainy' photon of light, with its relatively long wavelength and limited resolution; now images could be made via electrons, thereby achieving resolutions 1000 times greater.

This was the promise, at least, in the mid-1930s; electron micrography would not in fact become practicable for some years after its invention, and only since the early 1970s has the technology enjoyed widespread use. The early seventies represents a watershed in yet another important sense: until then – in fact, since 1895 – medical imaging techniques had shown the three-dimensional patient only as a two-dimensional image. With computed (or computerized) tomography (CT), invented in large part by Sir Godfrey Hounsfield in 1973, three-dimensional imaging of the brain became a reality, as did, for that matter, any slice through the body.

Since then, computers, robotics and microengineering have contributed to the evolution of imaging technologies. Positron emission tomography (PET), for example, replaced CT, which had been limited to pictures of the brain's anatomy (so, for example, it might show dead areas which had been starved of oxygen after a stroke) with

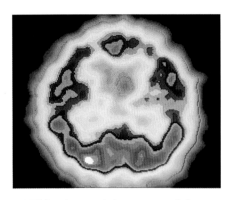

A PET (positron emission tomography) scan of a section through the brain

pictures of a living, functioning, fully awake human brain and its continuous metabolic activity. Ultrasound and magnetic resonance imaging (MRI) are equally dramatic developments with profound implications for future diagnostic and healing functions, since sound waves and magnetic fields do not carry the risks associated with radiation.

The images in this book have been produced in the last several years and represent the most advanced procedures that are available today for specific imaging tasks. To the layman, the variety of the techniques may appear bewildering, while their hi-tech names do little to aid comprehension. However, the *essence* of each technique is not difficult to grasp. Moreover, the differences between a number of the processes are relatively minor, and they can therefore be grouped (albeit crudely), into 'families'. Although this is not intended as a technical book, it would be helpful for readers to familiarize themselves in a general way, first with these families and then with the fundamentals of each of the important techniques.

What, precisely, *are* we looking at when we turn these pages? Are these bodies (or parts of bodies) those of normal, healthy *living* human beings? Are the colours *real?* The answer to the first question is generally, but not always, yes; it must be qualified. The answer to the second question is sometimes yes and sometimes no; again, the answer must be qualified.

First, a number of the techniques can be performed on *the living human body.* Gamma camera scans, fundus camera photography, magnetic resonance imaging (MRI) and ultrasound are examples of 'non-invasive' (or non-surgical) techniques of imaging the body. However, some require the introduction of foreign substances (orally or intravenously) in order to produce a legible picture. Endoscopic photography is also performed on the living body; it is minimally 'invasive', with the picture-making apparatus inserted through a natural orifice or a tiny hole which has been surgically prepared.

Many other procedures require a sample of tissues or organs to be *removed from the living body* for imaging. The various forms of photomicrography fit into this category. Light micrographs, scanning electron micrographs (SEMs) and transmission electron micrographs (TEMs) require special preparation of the tissue samples before they can be produced. However, while it is obvious that living and non-living tissue can be viewed and photographed under a light microscope, electron microscopes can only function with non-living and thoroughly desiccated (that is, dried) matter, as the instruments function in a vacuum and a vacuum cannot sustain life.

Lastly, it almost goes without saying that conventional photography can be utilized to depict internal organs and tissues exposed during medical operations in the case of the living and during autopsies in the case of the dead. Fundus camera imagery and radiography, usually associated with the living body, can also be used with non-living organs and tissues either *in situ* or removed.

In sum, these varied techniques allow image makers to choose those appropriate to their intentions, whether for the purposes of medical diagnosis, pure scientific research, or instruction. As this book is concerned with the normal, healthy human body, the images selected (with the obvious exception of Chapter 6) are of bodies and body parts which are free from disease. An image is considered successful by its maker if it can be said to replicate precisely what the trained observer sees on his or her instrument.

What, minimally, should the reader know of each of the processes featured in this book? There are essentially three families of images: Scans, Micrography and Photography. A brief explanation of these processes follows.

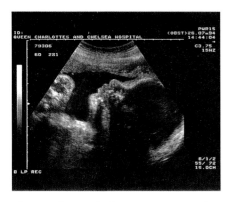

Ultrasound scan of a fetus at approximately 7 months

I. Scans

Gamma camera scanning is the process of recording radioactive emissions given off by a tracer (an isotope, such as Technetium-99m or Iodine-131) after it has been injected intravenously into a specific region of the body. The gamma camera houses a scintillator which gives off variable light as it is struck by radiations of different intensities. This light pattern is recorded, forming the image (p. 41). The image, viewed simultaneously, is said to be in 'real time'.

Magnetic resonance imaging is based on the behaviour of the nuclei of hydrogen atoms (in the subject's body) when they are placed in an intense magnetic field, which results in all the atoms temporarily orienting themselves in the same direction (in normal conditions they are all oriented in different directions). When a pulse of radio waves is directed at this field, the atoms are knocked out of alignment and reflect the waves back at the scanner. A computer interprets the data and produces a monochrome image on a video monitor, which is often coloured electronically at the time, or coloured later by hand (p. 123). MRIs also take place in 'real time'.

Ultrasound scans produce images by bouncing high-frequency sound waves off tissues. Different tissues reflect the waves differently and these reflections can be detected by a transducer and registered. Ultrasound is routinely used to monitor the developing foetus.

Positron emission tomography (**PET**) scans are obtained by injecting a tracer labelled with a short-lived radio-isotope (C-11 or radio-labelled H_2O) into the bloodstream; this emits positrons which are recorded by a detector through which the subject is passed. The method can be used to show various chemical activities in the brain, such as protein synthesis.

Radiography produces **radiograms** (commonly known as 'X-rays'). The images result from X-rays which pass from the emission source through the subject onto a recording emulsion. The picture is formed by the different exposures created by varying rates of absorption.

However, a problem arises when organs and soft tissues have a similar degree of transparency such that no differentiated image would be produced; this is overcome by filling them temporarily by injection or ingestion with radiographically more visible substances such as various iodine or barium sulfate solutions which are opaque to X-rays (p. 73). Sometimes the X-ray technique is described in terms of the function it fulfils or the area of the body it depicts (e.g., a **Urogram** shows the urinary tract [p. 79]). The radiogram may be coloured to show the structure or function more clearly.

Angiography is a general term embracing X-ray techniques for the examination of blood vessels. **Arteriography** is a specific technique for arteries; **venography** for veins. A radio-opaque medium is injected into blood vessels in the region where a picture is required and the subject is then X-rayed (p. 60). Like the gamma camera scan the image is seen in real time.

Computed tomography is an X-ray technique in which low doses of rays, each lasting fractions of a second, are passed through the body from different angles, producing a cross-sectional slice of the body in real time (p. 62).

Xerography is an X-ray technique that produces good contrasting imagery using a selenium-covered aluminium plate instead of photographic film.

X-ray tomography is a means of avoiding the problem of one organ or part of the body obscuring another in the image; both the X-ray gun and the recording plate move during the exposure, blurring all but the organ of interest.

II. **Micrography**

A **photomicrograph** is simply a photograph taken with the aid of a microscope. Conventionally the term **macrophoto** is used for magnifications from life-size to 10x, and the term **micrograph** for higher magnifications. A **light micrograph** continues to hold good resolution up to magnifications of approximately 1000x, though the range shown in this book is 10x to 400x (p. 74). Further resolving power, up to approximately 1200x, can be obtained if oil is placed between the subject and the lens.

There are further varieties of **light micrograph**. **Polarized light micrographs** (either the light source is polarized or a polarizing filter is positioned in the microscope itself) result in brilliantly coloured images, especially useful for depicting the surface crystal structure of bone (p. 45). **Fluorescent light micrographs** respond to the fluorescent dyes used to stain specific tissues (p. 23). This kind of micrograph can also be used to record the intense fluorescence produced by the natural pigmentation of certain tissues when irradiated with ultraviolet light. **Immunofluorescent light micrographs** are the result of a far more complex procedure whereby an antibody molecule (part of the immune system) is used to carry dye to a specific tissue or cell to which it attaches itself, thus 'lighting up' the cell structure when viewed under specific wavelengths of light (p. 48). A researcher can use different dyes to look at different structures in the same tissue. Finally, a **digital light micrograph** (or **video light micrograph**) is a light micrograph transferred into pixels onto a video screen; much medical diagnosis is performed using this technique.

Beyond a magnification of approximately 1200x, detail and resolution are lost. The image is, as the specialists say, 'empty of signification'. This is because the resolving power of the microscope – the ability to make tiny, closely spaced details visually distinct – is a function of the wavelength of energy that is used to illuminate the subject. Because electrons are smaller in wavelength than photons (we might say that photons are too 'grainy'), in **electron micrography** magnifications are possible without reaching the stage of empty signification. More than half the images in this book are either **scanning electron micrographs** (**SEMs**), which allow for views *10,000 times smaller than the human eye can see*, or **transmission electron micrographs** (**TEMs**), which allow views *100,000 times smaller*. Electron micrography employs electric or magnetic lenses rather than the optical lenses of a light microscope.

Because the electrons of a **TEM** pass *through* the specimen, the latter has to be extremely thin. **TEMs** cannot therefore be used in the study of three-dimensional aspects of a specimen, or uneven surfaces. These difficulties are resolved by **SEMs**, in which the electrons bounce off the surface of the specimen, thus allowing the surfaces of whole, minute objects or creatures as well as surfaces as small as individual cells to be observed.

The actual images we see from each type of electron microscope are formed differently. In the **TEM** the image is formed on a fluorescent screen within the column. Once the image is focused the screen is flipped away and a camera substituted, with the film exposed to the electrons which have passed *through* the specimen; in the **SEM** the electrons *bouncing off* the surface give rise to varying voltage signals (electric currents) which are then led out of the microscope column to a television screen, and this in turn is recorded by a conventional photographic camera and film. The **TEM** instantaneously provides a whole picture, while an **SEM** builds up a picture bit by bit.

TEMs, which are used to look inside cells at their structures, allow much higher magnifications than do **SEMs**, even to the extent of depicting individual atoms. The

slice of the subject is very thin, and dyes may also be used. A negative staining technique lights the subject by making the background dark; a **freeze-fracture TEM** takes a dried subject, freezes it using liquid nitrogen, then breaks it. It will break along natural fracture zones rather than, as in a clean cross-section, precisely in half; for example, this procedure allows the scientist to look at the surfaces of the nucleus.

The amount of work in preparation of slides for microscopy should not be underestimated. Many hours may be spent with the samples, and literally hundreds of thousands of cells may be prepared, manipulated and studied closely before a choice is made for the purposes of image-making. How and when living cells are killed are only two of the decisions which must be made by the image maker, as their state is in flux. In the case of preparation for immunofluorescent work, time is critical because the dyes employed to mark the tissues fade rapidly when exposed to fluorescent light. The photography must be accomplished very quickly.

III. Photography
Macrophotography is a confusing term which is often used to mean photography on a scale of one to one; but it can also mean (as we have discussed with photomicrography) magnifications up to 10x.

Fundus camera imagery uses a highly specialized magnifying apparatus engineered to peer inside the eye at the retina or the lens (p. 22). The eye may be injected or its surface washed with a fluorescent dye which illuminates aspects of retinal structure.

Endoscopic photography is produced with a device composed of a tube, inside of which are a series of lenses and a fibre optic light source which is then inserted at some point into the body. The reflected light travels back through the tube to a still camera outside the body or a real time video display (p. 61). Although it is today commonly used to look inside knee and other joints, the procedure was made famous by Dr Lennart Nilsson's pictures of the living fetus in 1965.

Schlieren photography is used to record otherwise invisible patterns of air and gas turbulence, such as a person coughing, sneezing or exhaling.

What can be said of the colour of these spectacular images? Is it real or artificial? The answer is particular to each technique.

The image its maker sees through a *light* microscope is coloured, since colour is a property of light. This colour may be a natural attribute of the subject, or it may be due to various staining techniques which are used to differentiate tissues, or it may result from the type of illumination employed (polarized light, for example, produces brilliant colours which demonstrate the structure of crystal very effectively). Obviously colour film will accurately record what is seen by the observer if this is what is required. But equally a black and white photograph may be made and portions then coloured photographically, or by hand, to differentiate detail.

There is another reason for staining tissues which has nothing to do with wanting the image itself to be in colour: because biological sections are thin, transparent, and low in contrast, they must be stained in order to produce a legible image, that is, one of sufficient contrast. Different stains are routinely used to differentiate structures; for example, eosin colours cytoplasm pink; haematoxylin stains cell nuclei blue.

There are also more complex colouring methods, resulting from the controlled chemical reactions of enzymes or, as we have seen, antibodies tagged with fluorescent

A Schlieren photograph of a man sneezing. Schlieren photography shows up turbulence in the air

dyes. Double or triple exposures may be made, one per colour, with the image maker seeing the final 'mix' only after the film has been developed. Or, the same specimen can be photographed using different combinations of filters to reveal different colours and therefore different structures. But the goal always remains the same: to differentiate and clarify.

Unlike conventional light micrographs, electron micrographs are by their nature monochromatic, since electrons, unlike the photons of natural light, do not carry colour. However, it has become standard practice to colour these images by hand, by computer or by photographic methods, not only for the reasons given above, but also for aesthetic effect. However, no universal colour code has evolved and the same tissue or structure in one image may appear in different colours in another.

With electron micrographs tissues are stained not for colour, but for contrast (since colour is not visible as such).

With any computer imaging system, colour can be arbitrarily assigned to the image. MRIs are black-and-white images which are often coloured for ease of viewing and instruction. Ultrasound scans of the fetus are also usually black-and-white, but it is likely – such is the parental demand for a first 'baby portrait' – that these will soon be coloured. Ultrasounds of blood flow, however, are coloured. X-rays are generally not coloured for diagnosis but often are for the purpose of instruction.

The subjects of endoscopic images show their natural colouration, as do Schlieren photographs.

Why is colour added to monochromatic images other than to differentiate detail? In large measure because it is designed to be, to use a current expression, 'user friendly'. The lay viewer of the later twentieth century, attuned to a world of colour representation (films, television, magazines, publicity, product packaging and so on), expects colour – indeed, demands it. Moreover, he or she expects that colour to correspond to his or her preconceptions about what is natural (in a PET scan of brain activity what we think of as a cool colour would be used to indicate low metabolic activity, for example, while a red blood cell in a monochrome SEM will normally be coloured red). Similarly, background colours will be chosen which correspond to normal perception (for example, colours which reverse figure/ground relationships are avoided). Only when an image is intrinsically abstract is its maker free to colour it in following his or her own inclination without risking incomprehension on the part of the viewer.

In the case of fluorescent dyes, the image maker must work with what is available for specific needs; for various reasons too complex to explain here, Dr Nancy Kedersha usually works with a palette of three colours (red, green and blue), which sometimes (depending on the proximity of the tissues being observed) allows her to produce two additional colours by combining them.

As the kinds of images featured in this book are much in demand for the purposes of illustration and instruction, every effort is made by the makers to aid the viewer in his or her interpretation and understanding. Dr Jeremy Burgess, who has long specialized in the post-production colouring process, reminds us that the images are commercial products and are therefore required to look attractive to a public weaned on colour television. Indeed, Dr Pietro Motta first coloured his monochrome SEMs at the request of Italian television producers.

Does admitting that a prime function of this state-of-the-art imagery is educational (or even for entertainment) call into question the claim that it represents a *frontier* of

science? There are two schools of thought on this issue. Dr Burgess argues that the frontier is within the microscope; the moment of observation is the moment when discoveries are made, and a photograph of what is being observed taken at the time is a useful record of a moment of discovery *which has passed.*

Dr Kedersha, on the other hand, maintains that the images may actually contain more information than we currently comprehend or even *recognize*. She is able to point to structures which, though visible in an image taken years ago, were not noticed at the time. With new knowledge we are able to go back to those images and glean valuable information from them. In this sense they *do* continue to represent a frontier.

Whatever the validity of this argument, the scientific and diagnostic value of the images is undeniable. But what of their aesthetic value? Indeed, is there any real justification for speaking of art where scientific imagery is concerned?

Martin Kemp, a historian of both art and science, reminds us that all pictorial means of representation, and not *just* the imagery produced by these new techniques, these 'instrumental systems of perception', have, by definition, an element of artistry.

> Whether we are dealing with an artist making a detailed rendering, a photographer who judges lighting, exposures and printing, or a technician adjusting the emission and parameters of the receiver in an ultrasound scan, complex series of choices are made, which involve what we may call artistry, in the sense of using skill to give a selective, effective and even appealing depiction. (*Materia Medica: A New Cabinet of Medicine and Art* [Ex. cat.], Ken Arnold and Martin Kemp, The Wellcome Institute for the History of Medicine, London, 1995, p. 13)

The image makers themselves, for the most part highly trained and experienced scientists, have their own specific thoughts about the subject. Generally they accept that there is an aesthetic to their work but stress that it falls within narrow confines. 'Art for art's sake' is anathema in this field; artistic license is only granted provided scientific goals are not compromised (framing an image for the sake of an artistically pleasing result while ignoring scientifically interesting structures would not be acceptable). On the other hand, composition and colour do offer certain limited choices and freedoms, as indeed we have seen with the element of colour.

However there is another, more profound yet elusive level at which aesthetics is an issue. For Manfred Kage, much of the imagery has 'quite a prominent aesthetic dimension'. Kage, who has studied art as well as chemistry during his formative years, relates the initial quest for an image to Marcel Duchamp's 'objet trouvé': in his own practice, he must discover a potential image from thousands of samples he has carefully prepared on half-a-dozen glass slides. He likens his role to that of a hunter. Kage has also been influenced by the Surrealist painters, whom he admires for their clarity, precision and reliance on the unconscious and the dream. Painters like Lyonel Feininger and Max Ernst, Kage maintains, were certainly trusting their intuitions when they worked, but they were also tapping into the fundamental principles of organic form. The abstract and semi-abstract world they and their fellow early-twentieth-century artists created bears an uncanny resemblance to the 'microcosmos', as it has been called by Jeremy Burgess and others. It is as if the insights and visions of the artists, relying on intuition rather than evidence, seized upon an invisible reality which would only be confirmed, and charted, in the last quarter of our century, by scientists.

Robert Davies, *Ear III*, 1993. From the series
'Skin'. Gelatine silver print

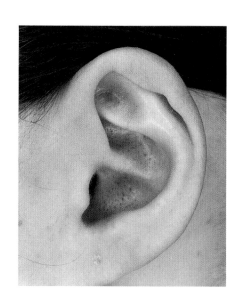

1

SENTINELS

THE SURFACE OF THE BODY AND ITS SENSE ORGANS

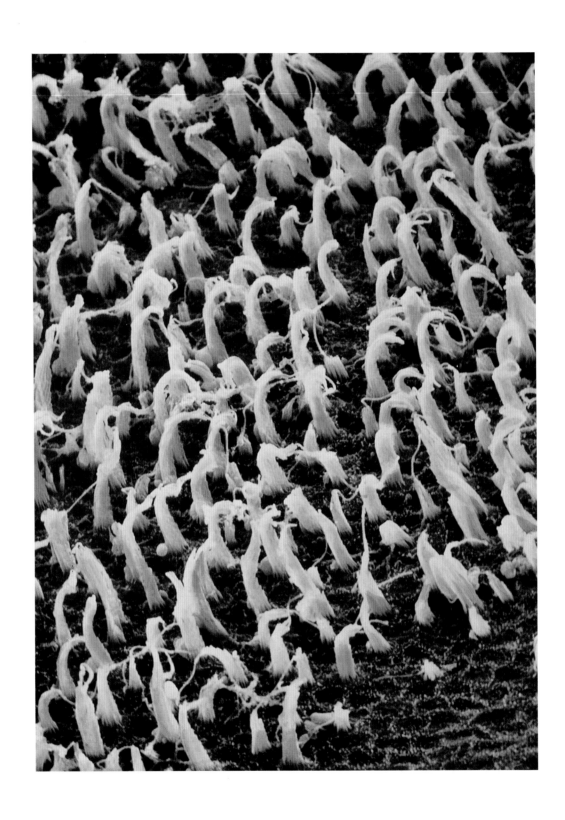

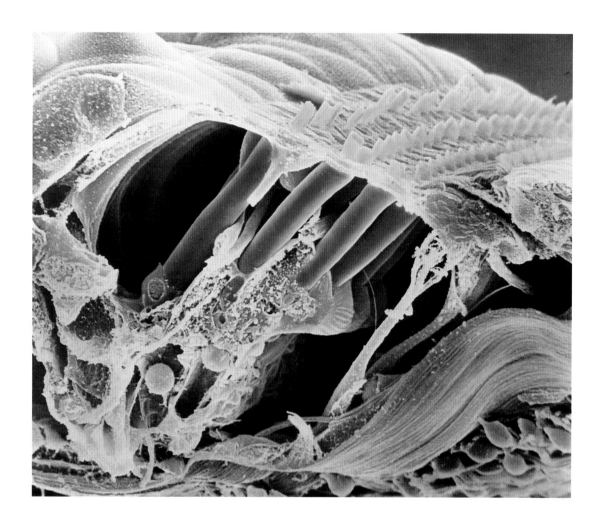

Opposite

THE BALANCE MECHANISM. The ear has two basic functions: to help maintain balance and to react to sound. The image *opposite* shows the macula, a part of the inner ear which is concerned with the first function. In the macula, the ciliated hair cells (*pink*) are stimulated if the head is moved up or down; they pass information to the brain which allows it to cope with these changes. Coloured scanning electron micrograph.
Magnification: x 3130. Professor Pietro Motta

Above

THE HEARING MECHANISM. The second function of the ear, that of hearing, also takes place in the inner ear, in the organ of Corti, shown *above*, in section. At top right can be seen four rows of hair cells. Each hair cell contains up to 100 individual hairs, whose function is to translate the mechanical movement caused by their displacement by sound waves into electrical impulses which are then transmitted directly to the brain. The organ of Corti contains more than 20,000 of these hair cells. Coloured scanning electron micrograph.
Magnification: x 1830. Dr G. Oran Bredberg

Above

THE EYE, showing the fibre-like cells that form the 4-mm-thick lens. The transparency of the lens is due to the fact that there are no nuclei in its cells, as well as to the crystalline precision with which the cells are arranged. The lines of cells are locked together by rows of ball-and-socket joints that look somewhat like zippers. Coloured scanning electron micrograph. *Magnification: x 6420*

Opposite top

THE EYE, showing the lens (*right*), the ciliary body (*left, top to bottom*) and the suspensory ligament, connecting the two. The ciliary body is the focusing muscle; it alters the shape of the lens in response to the nearness or distance of an object. Macrophoto. Ralph Eagle

Opposite bottom

THE FRONT OF THE EYE, showing the lens (*bottom right*), the lightly pigmented iris (*yellow, centre to right*), the ciliary body (*bottom centre*) and the junction between the clear cornea (*blue, centre to top right*) and the white of the eye (*cream, left*). Macrophoto. Ralph Eagle

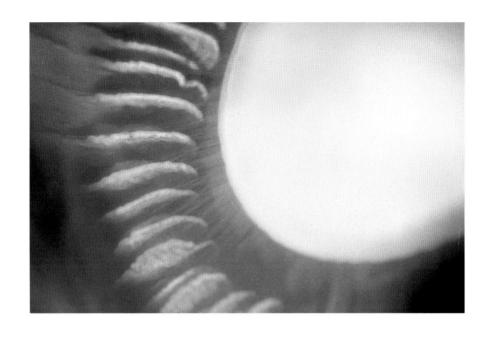

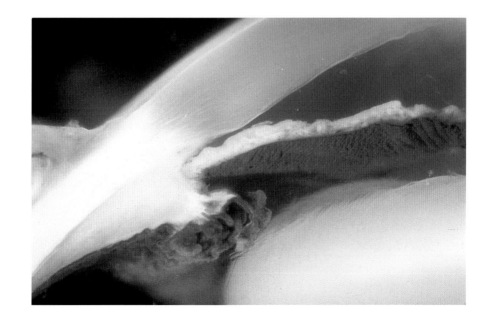

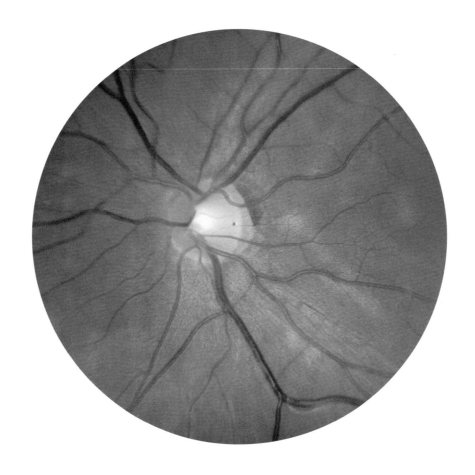

Above and opposite
THE RETINA OF THE EYE. The picture *above* shows the distribution of the veins and arteries in the retina. The retinal artery enters the optic nerve before it reaches the eyeball and emerges from the centre of the optic disc (the blind spot of the eye, the pale central area). On the right can be seen the dark edge of the macula, a region free of large blood vessels where the fovea (the area of highest visual acuity) is found. An extension of the optic nerve, the retina consists of photosensitive cells (rods and cones) which translate light energy into nervous impulses. Fundus camera image.
Rory McClenaghan

The image *below* shows how the photosensitive cells – rods and cones – are arranged in the retina. Cones appear as large yellow or green cells and rods as smaller units in a more regular arrangement. There are about 130 million rod cells and 6.5 million cone cells in the retina. Cones contain a photosensitive chemical, iodopsin, and are associated with daylight and colour vision. Rods contain rhodopsin (visual purple), a light-sensitive pigment which breaks down in bright light, and are receptors for night or low-light vision. Fluorescent light micrograph. E.M. De Monasterio

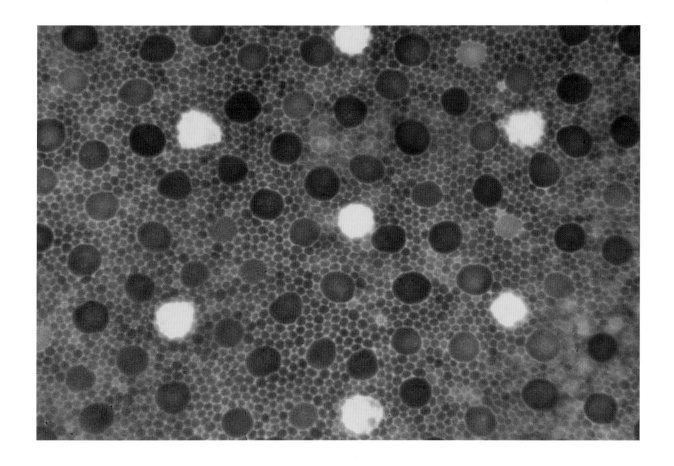

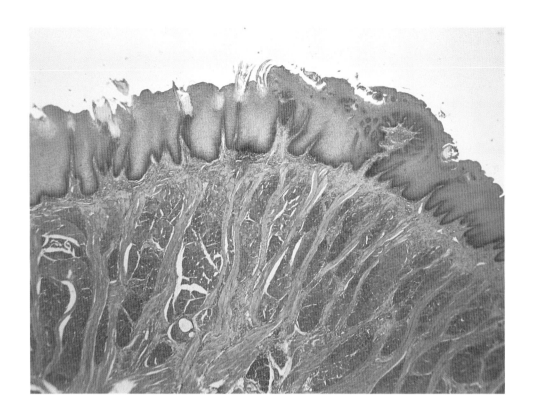

THE TONGUE, in section. The tongue consists of a mass of interlacing bundles of skeletal muscle fibres (lower two-thirds of image) which permit an extensive range of movements. The mucous membrane (top third of image) is firmly bound to the muscle by dense collagenous fibres. The surface of the tongue is covered with many tiny projections called papillae, the most numerous of which are the type known as filiform. These are the feathery projections seen here at the centre of the mucosal surface. Light micrograph. *Magnification: x 40.* John Burbidge

THE SURFACE OF THE TONGUE, showing the filiform papillae. These have both mechanical and tactile functions: they form a rough surface which helps in chewing, and they contain nerve endings which transmit tactile information to the brain. At the centre, yellow-coloured bacteria are also visible. Coloured scanning electron micrograph. *Magnification: x 1960.* Professor Pietro Motta

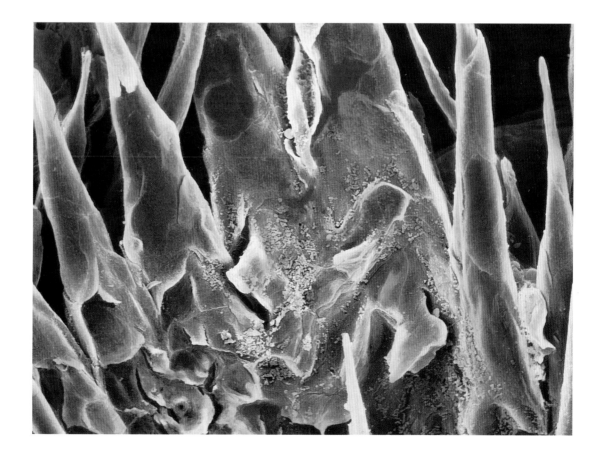

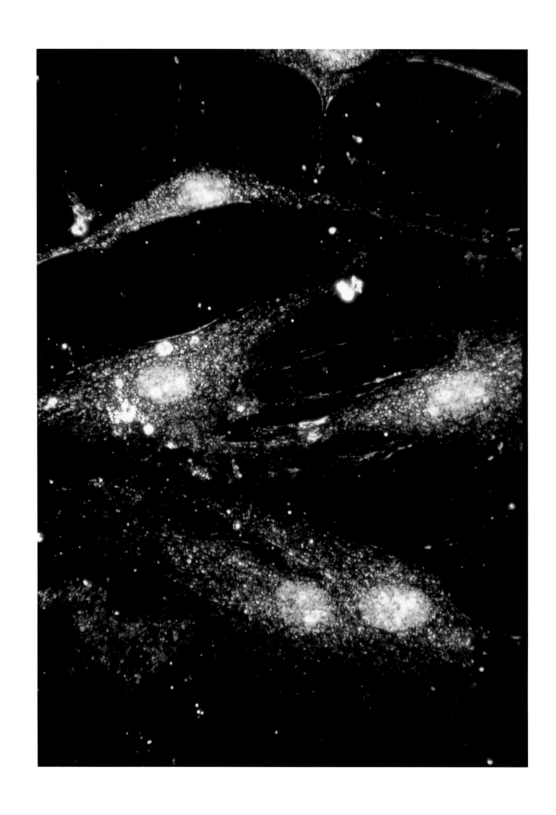

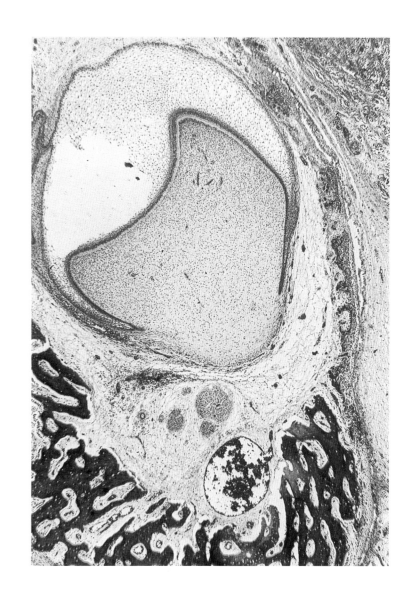

Opposite
THE LIP, showing epithelial cells, with prominent nuclei stained *yellow-green.* All body surfaces and cavities are lined with epithelial tissue, which is involved in a variety of functions, including absorption, secretion and protection. Light micrograph. Cecil H. Fox

Above
AN UNERUPTED TOOTH. The centre of the tooth appears as a roughly triangular structure. The crown is covered by a layer of enamel (*dense maroon*), under which is a layer of dentine (*light maroon*), which thickens as the tooth develops. The dentine layer encloses the dental papilla, a structure rich in dentine-forming cells, which forms the bulk of the embryo tooth. Light micrograph. *Magnification: x 60.* Astrid Kage

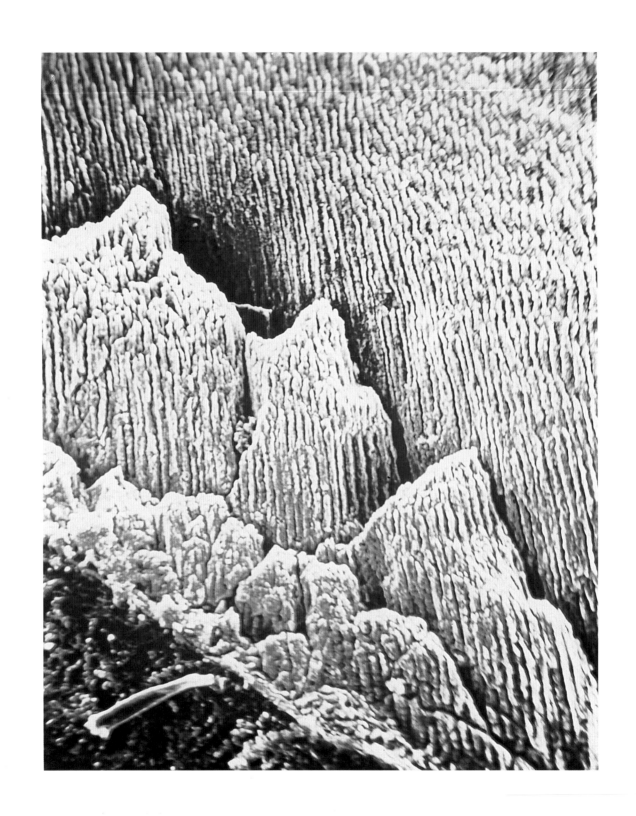

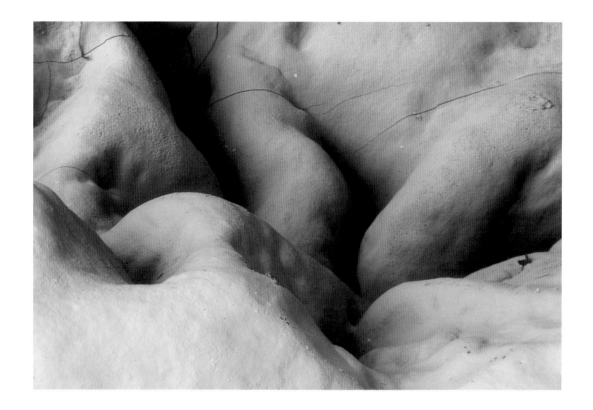

Opposite
TOOTH ENAMEL, the covering of the crown of a tooth. Enamel
is an extremely hard, translucent substance composed of
parallel rods, or prisms, of highly calcified material cemented
together by an equally hard, calcified substance. The prisms
are arranged perpendicular to the surface of the enamel.
Coloured scanning electron micrograph. *Magnification: x 490*

Above
A MOLAR TOOTH, showing the undulating surface, specially
adapted for chewing food. Coloured scanning electron
micrograph. *Magnification: x 30*. Manfred Kage

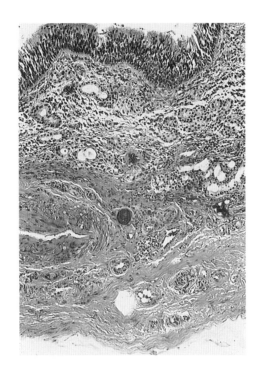

Above

THE SENSE OF SMELL. Here skin from the nose is seen in section, showing the area of tissue in the nasal cavity where the olfactory cells – responsible for the sense of smell – are located (*purple*). Beneath is a layer of connective tissue containing nerve fibres, blood vessels and serous – serum-producing – glands. Light micrograph. *Magnification: x 110*. Astrid Kage

Opposite

THE SKIN, seen in section, showing the layers of the epidermis (*red*) and the underlying dermis (*blue*). The two large rings are Pacinian corpuscles, seen in transverse sections. These are sensory organs, located deep in the skin, which respond to pressure or coarse touch, to vibration and to tension. They are also found in ligaments, joint capsules and other areas, as well as in some erogenous zones. Rather like an onion, the corpuscle consists of concentric layers of cells, fluid and connective tissue fibres which increase in density towards the single nerve fibre that lies at its core. Light micrograph. *Magnification: x 350*. Manfred Kage

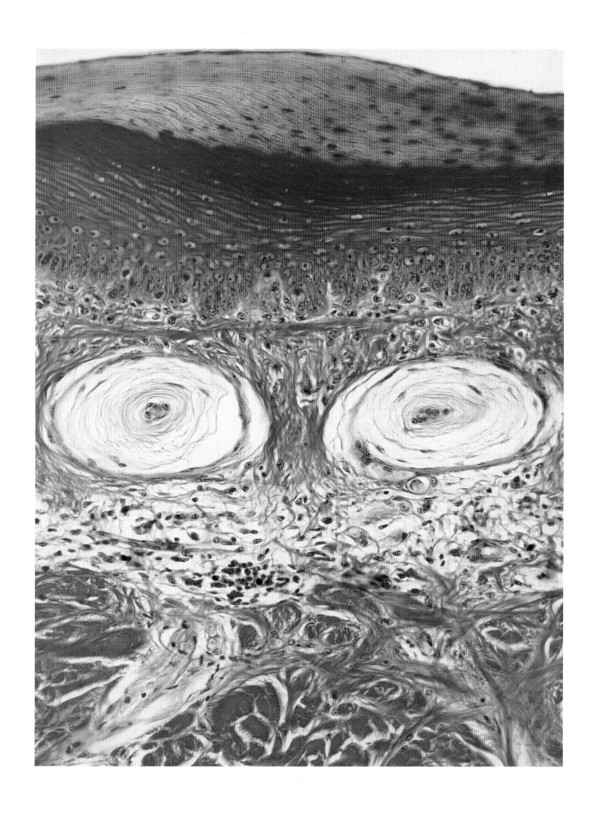

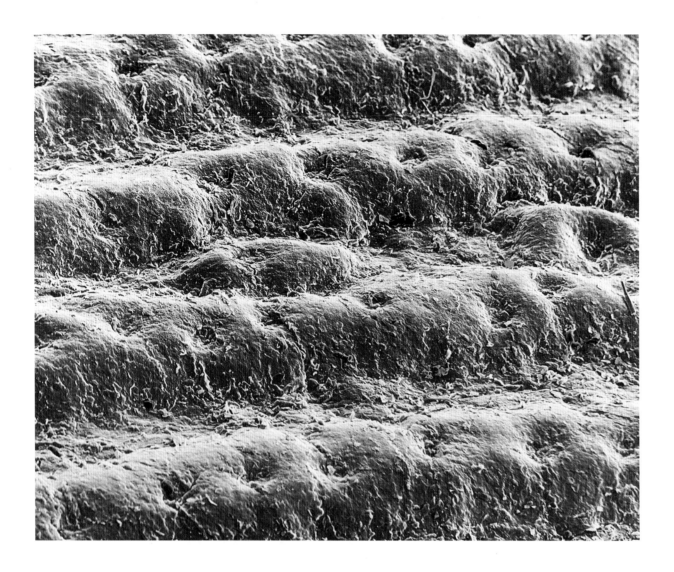

SKIN from the palm of a thirty-year-old man. The skin is neatly arranged in ridges, along which sweat pores are seen as miniature craters. The cells forming the external surface of the skin, the epidermis, have been flattened and hardened by the depositing in them of the fibrous protein keratin. This tough, dead layer of cells is continuously being shed and replaced by new, maturing cells which take a month to migrate from the base of the epidermis. Coloured scanning electron micrograph. *Magnification: x 60*. Dr Jeremy Burgess

SKIN from the underside of the finger-tip, seen in section, showing the epidermis folded in wavy ridges. The white layer is the 'horny' layer, composed of keratin. The dark red layer with finger-like projections is the germinal layer, from which epithelial cells migrate outward, becoming increasingly toughened. Beneath is the dermis, consisting of connective tissue, blood vessels and sensory receptors. Light micrograph. *Magnification: x 190*. Manfred Kage

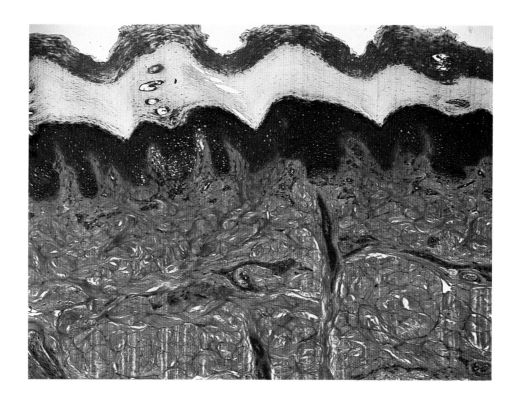

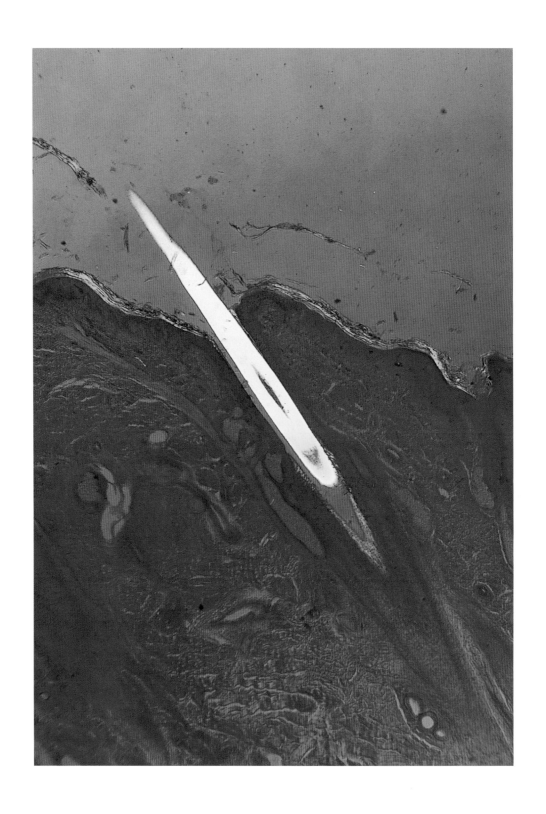

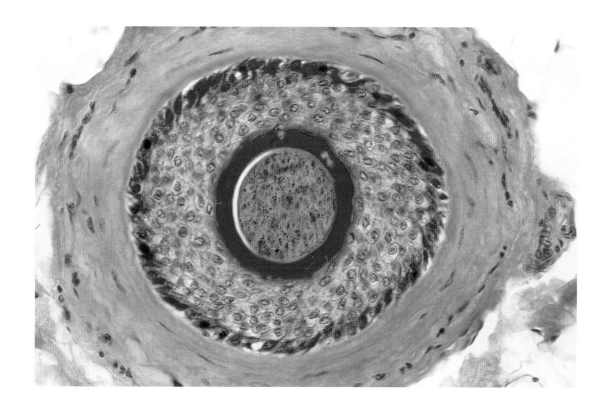

Opposite
THE SCALP, seen in section, showing a single hair shaft
(*yellow*). Hair is composed of a fibrous protein called keratin
which develops out of a tubular follicle located in the
epidermis of the skin. Hair cells are dead except for a region
within the hair or root bulb, at the base of the shaft, where
epithelial cells divide to form new cells, pushing the older ones
outward – making the hair grow. Curly hair may occur when
the follicles are curled or when the hair bulb lies at an angle to
the shaft. Each follicle has a bundle of smooth muscle which
makes the hair stand 'on end' in conditions of cold or fear, as
well as one or more sebaceous glands which secrete an oily
substance called sebum, which coats the surface of the hair
towards the upper part of the follicle. Light micrograph.
Magnification: x 265. Jean-Claude Revy

Above
WHERE HAIR BEGINS. This image of skin shows a cross-section
through a hair follicle. The hair root lies at the centre and consists of
horny epithelial cells. It is surrounded in layers by the inner epithelial
root sheath (*red*), the outer epithelial root sheath (*purple*) and a ring
of connective tissue (*blue with red nuclei*). Light micrograph.
Magnification: x 410. Astrid and Hanns-Frieder Michler

BEARD SHAVINGS on the edge of a razor blade (*blue*); skin flakes and remnants of shaving foam are also visible. A 'wet shave' using a razor results in the hair being cleanly cut, as shown here; an electric razor would show the hair as torn and mangled.
Coloured scanning electron micrograph. *Magnification: x 390.* Andrew Syred

AN INDIVIDUAL HAIR. A shaft of hair, with
residue on its surface (*blue*). The shaft,
which consists largely of the protein keratin,
has an outer cuticle of flat, overlapping
scales or plates which, it is thought,
prevents the hairs from matting together.
Coloured scanning electron micrograph.
Magnification: x 1500. David Scharf

Lynn Davis, *Bones #2*, 1991.
Gelatin silver enlargement print

2

FOUNDATIONS

THE STRUCTURE OF THE BODY;
ITS BONES, CONNECTIVE TISSUE
AND MUSCLES

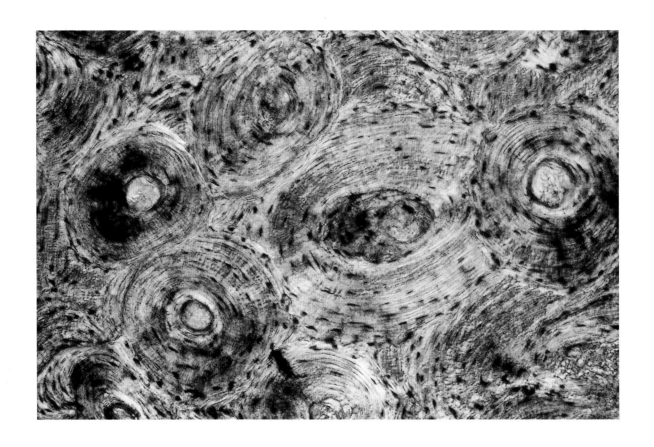

COMPACT BONE. There are two kinds of bone: compact bone and cancellous bone. Compact bone is dense and hard and is found in long bones. This image shows how this kind of bone is organized. Concentric bony layers (lamellae) are arranged around channels containing blood vessels, lymph vessels and nerves. The lamellae and the channel together form a 'Haversian system', several of which are seen here (see also page 43). Light micrograph. *Magnification: x 265.* Claude Nuridsany and Marie Perennou

THE HEAD AND NECK areas of a healthy person. This kind of scan measures the radiation uptake in bone, and is used to assess the presence of secondary bone cancers. Cancerous bone produces a brighter, 'hotter' area on the image. Coloured gamma camera scan or scintigram

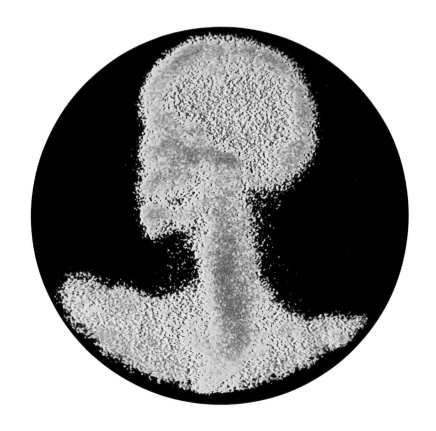

Above
BONE AID. A bone cell, or osteoclast (*gold*), can be seen here surrounded by a frayed series of collagen strands (*blue*). Osteoclasts are cells which absorb old bone and play a part in the remodelling of bone in response to growth or mechanical stress on the skeleton. They also help to maintain blood calcium levels. Coloured scanning electron micrograph. *Magnification: x 670*. David Scharf

Opposite top
COMPACT BONE. This image shows a ground and polished section of one Haversian system, from which all organic components have been removed. Coloured scanning electron micrograph. *Magnification: x 540*. Professor Pietro Motta

Opposite bottom
BONE LAMELLAE. Lamellae, the bony plates that surround Haversian canals are made of compacted collagen fibres and salts of calcium phosphate and make up the bulk of compact bone. They are produced by cells known as osteoblasts, the body's 'bone-builders'. Coloured scanning electron micrograph. *Magnification: x 1860*. Professor Pietro Motta

Below
BONE LAMELLAE in crystal formation. Here, taken from fractured bone, the lamellae are in the unusual form of a rosette. These crystals, which are of similar thickness, have been colour-coded according to how mature they are. Usually they are arranged into concentric layers of tight circles, with more mature lamellae on the outside (see opposite). Coloured scanning electron micrograph. *Magnification: x 1770*. Professor Pietro Motta

Opposite
BONE TISSUE. In the area on the left, rings can be seen which correspond to concentric bands of lamellae, centred round a Haversian canal. Each small dark spot is a lacuna, a hole in the bone which is occupied by an osteocyte or bone cell. The active form of the osteocyte is the osteoblast cell, responsible for bone formation (see also page 43, bottom). Polarized light micrograph. *Magnification: x 110*. Manfred Kage

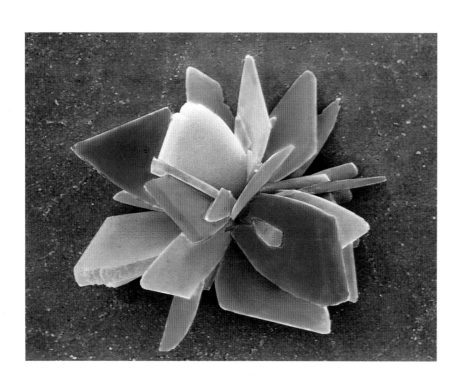

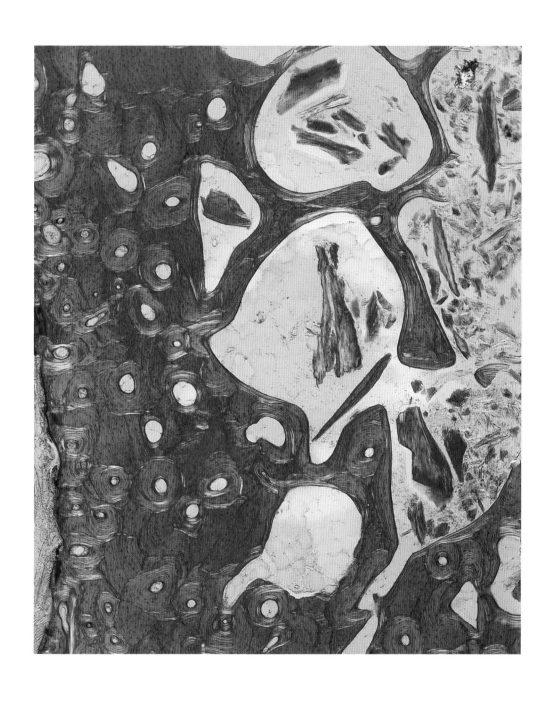

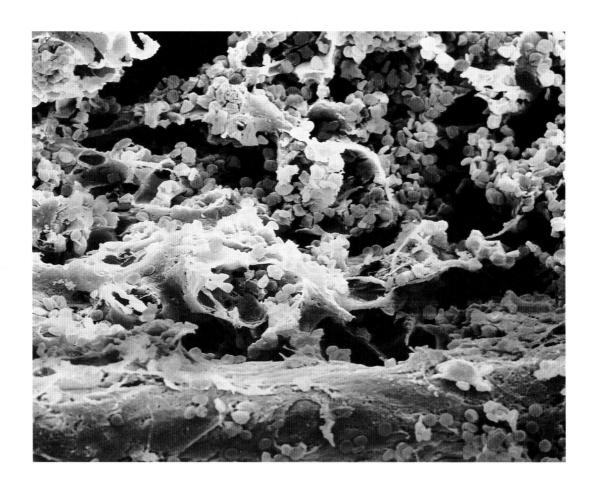

BONE MARROW is the soft centre of bone. In it both red and white blood cells are produced. At birth, all bones are full of red, or active, marrow. In adulthood, the marrow becomes less active and the red marrow of the long bones is replaced by yellow marrow, composed mainly of fat. This image shows developing red blood cells and some of the channels that traverse the marrow. Coloured scanning electron micrograph. *Magnification: x 690*. Professor Pietro Motta

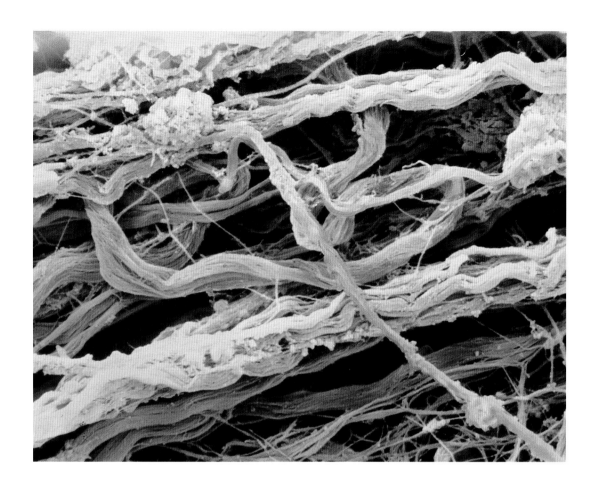

A MAJOR SUPPORT SYSTEM. Connective tissue provides structural and metabolic support for other tissues and organs throughout the body. It is partly made up of bundles of collagen and elastic fibres, shown here. Collagen fibres are formed by a protein, collagen, which makes them strong but not stretchable. Elastic fibres, on the other hand, are made of elastic protein and they enable tissue to recover its shape after it has been deformed or stretched. Coloured scanning electron micrograph. *Magnification: x 8360*. Professor Pietro Motta

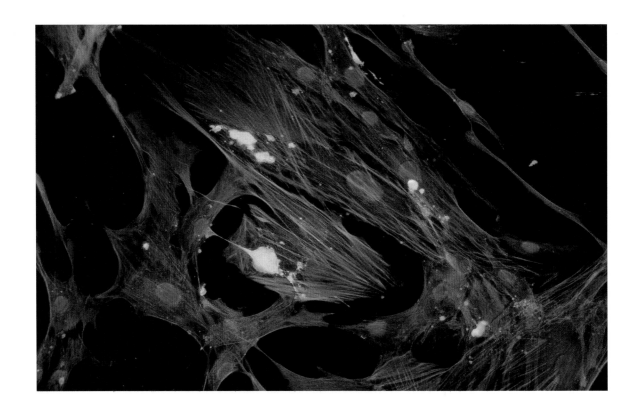

BODY BUILDERS. The fibroblast connective tissue cells shown here have been taken from fetal skin. Fibroblasts are responsible for forming connective tissue by secreting matrix material such as collagen and fibronectin. They also play a role in the formation of bone and cartilage. Fibronectin is stained *red*; cell nuclei, *blue*; actin stress fibres, *green* (see also pages 47 and 50). Immunofluorescent light micrograph. *Magnification: x 270.* Nancy Kedersha

AGENTS AGAINST AGEING. Collagen is the principal component of white connective tissue. Here the fibrils of collagen (*red*) have been shadowed with a heavy metal to show their banded structure. Collagen is a tough, fibrous protein, found in the skin, cartilage, bone, ligaments and tendons. Its molecules are put together like ropes with three strands. Many of the processes of ageing are due to alterations in this structure. Coloured transmission electron micrograph. *Magnification: x 29,520.* J. Gross

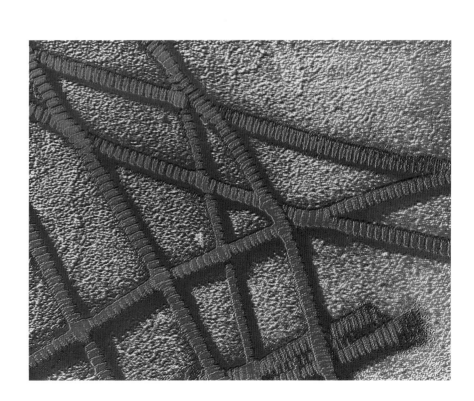

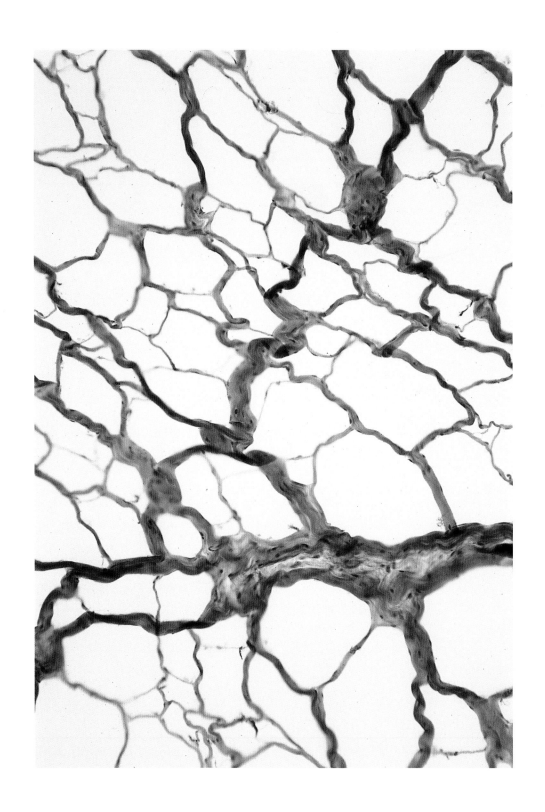

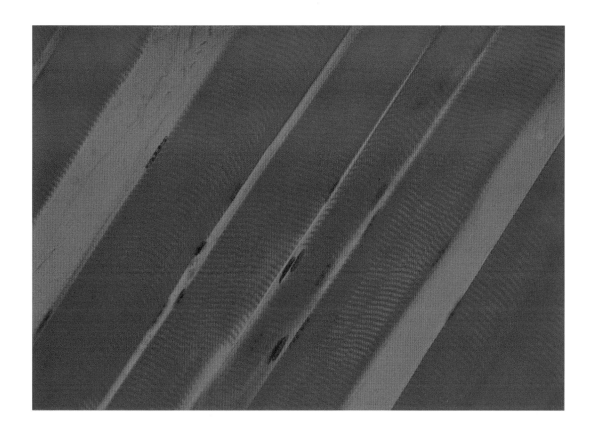

Opposite
THE SUPPORT NETWORK. This image shows a network of connective tissue. Apart from its presence in bone, cartilage, tendons and ligaments, connective tissue can also be found in fat tissue, breast tissue, the elastic tissue in the skin, artery walls, and air sacs of the lungs. Light micrograph.
Magnification: x 130. Astrid and Hanns-Frieder Michler

Above
CONTROLLING MOVEMENT. The most common muscle in the body is striated muscle, shown here in section. Also known as skeletal muscle, it is responsible for voluntary movement and is called 'striated' (striped) because of its prominent banding (see also pages 52-53). Polarized light micrograph. *Magnification: x 580*. Michael Abbey

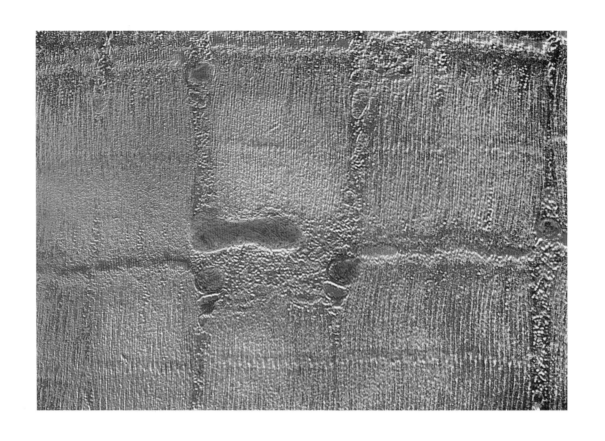

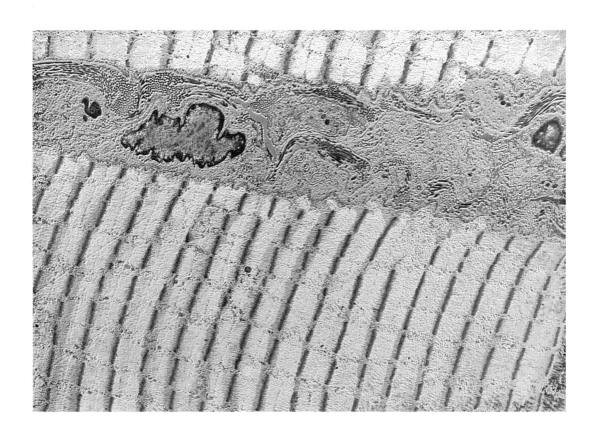

Above and opposite
STRIATED MUSCLE. These images show the organization and banding pattern of the myofibrils in striated skeletal muscle tissue (see also page 51). Myofibrils are long, thin threads made up of proteins. They can be seen above, coloured yellow, between the striations. The proteins slide over one another, to shorten or lengthen the muscle. Coloured transmission electron micrographs.
Above: Magnification: x 21,840.
Opposite: Magnification: x 3100

Andrea Owen, *Circulation Figure*, 1995.
Etching on lithograph

3

EXCHANGES

THE BODY'S RESPIRATORY
AND CIRCULATORY SYSTEMS

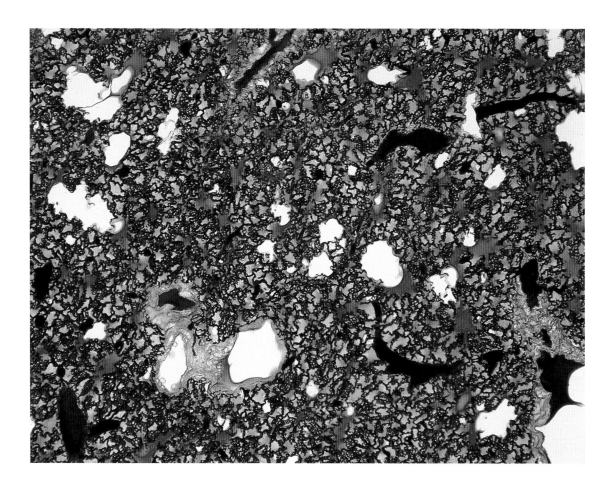

Above

LUNG TISSUE, in section, showing numerous small air spaces (alveoli) (*red*) surrounded by a fine network of blood capillaries (*blue*). Air enters the lungs via the bronchi, the air passages, which divide repeatedly to form airways of ever-decreasing diameter. The very last branches of this respiratory tree open into the blind-ended alveoli (shown here), the air sacs where gas exchange takes place. The lungs contain around 7 million of these. The network of capillaries in the walls of the alveoli carry deoxygenated blood from the right side of the heart. The blood absorbs oxygen and releases carbon dioxide through the thin alveolar walls. This exchange of gases is called 'external respiration' (see also page 59). Light micrograph. *Magnification: x 50*. Astrid and Hanns-Frieder Michler

Opposite

THE LINING OF THE WINDPIPE. The trachea, or windpipe, is lined with cilia, which look like wormy threads, and which hide the underlying cell surface. Interspersed among these are goblet cells (*left, blue*) which secrete a viscid mucus to keep the trachea moist and trap any dust that has been inhaled. This mucus is constantly being moved upwards, away from the lungs, by the undulating movements of the cilia. Coloured scanning electron micrograph. *Magnification: x 9600*. Professor Pietro Motta

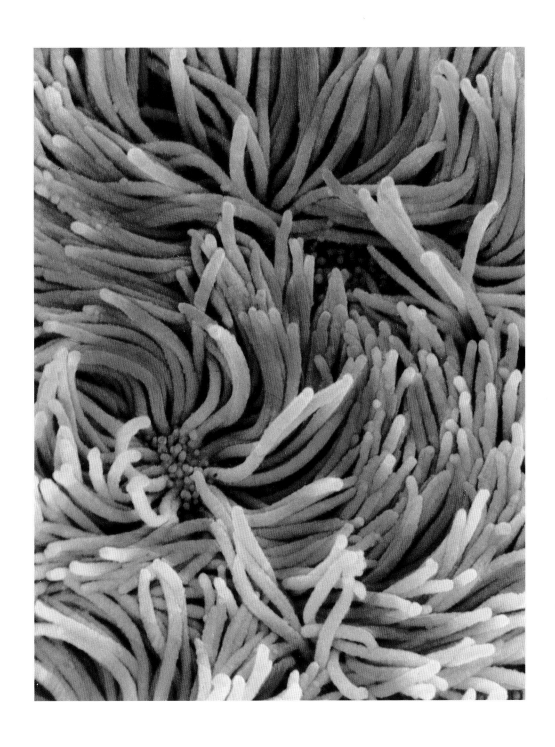

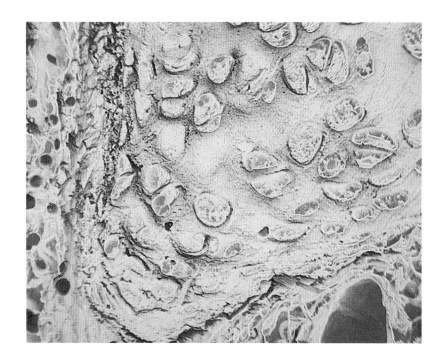

Above
THE LUNG. Hyaline cartilage from the walls of the bronchus, the main conducting airway of the lung. Hyaline cartilage is the most common cartilage in the body. It is also found in the walls of the trachea, or windpipe. This image shows the organization of chondrocytes, or cartilage cells, which are embedded in a cartilage matrix which the cells have synthesized. Coloured scanning electron micrograph.
Magnification: x 790

Opposite
LUNG TISSUE, showing an alveolar septum, the partition between air sacs where gas exchange takes place. Blood vessels extend across the entire septum, coloured yellow in this image and filled with red blood cells (*dark red*). The dark-pink-coloured cell in the centre with a large nucleus is one of the two alveolar cell types (see also page 56). Coloured transmission electron micrograph.
Magnification: x 5460

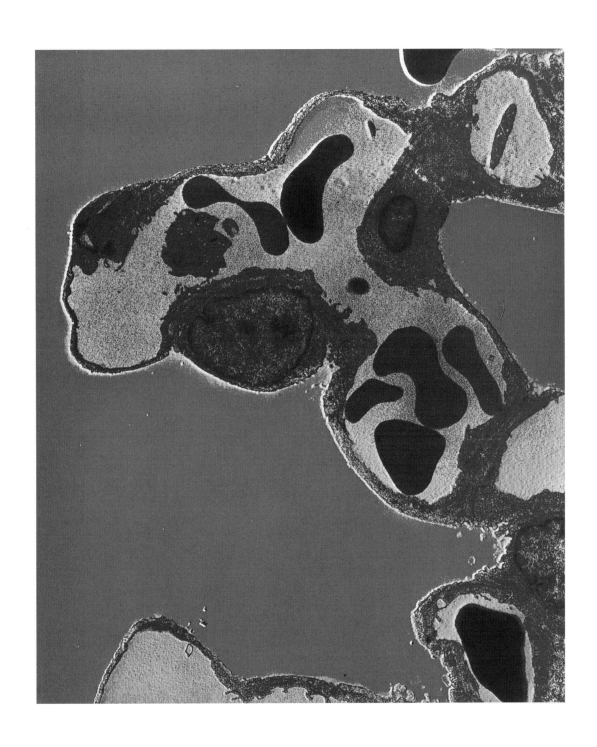

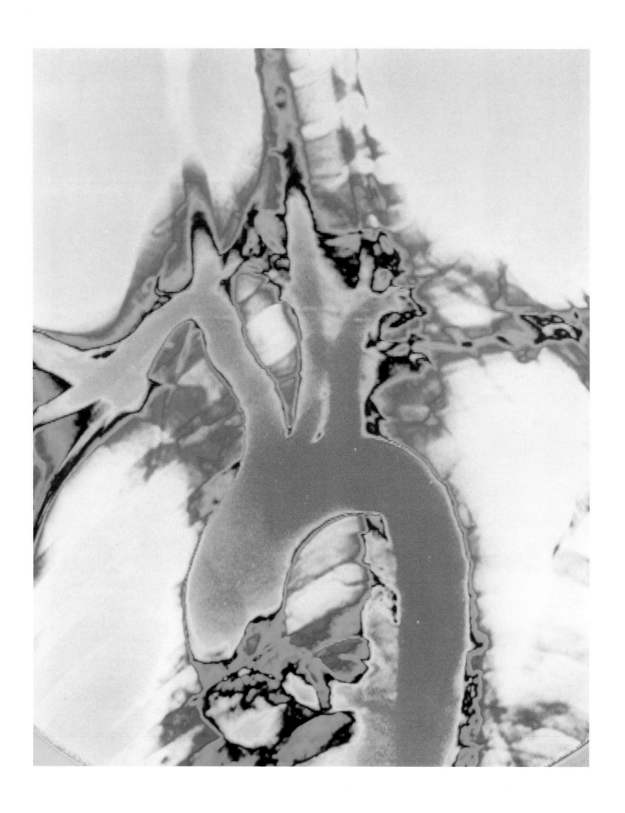

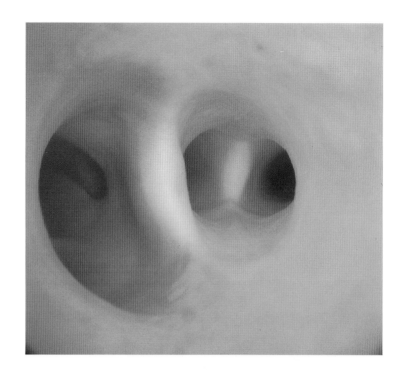

Opposite
THE ARTERIES OF THE BODY. Shown here are those
arteries that arise from the aortic arch (*orange,
bottom*), the section of the aorta that curves over the
top of the heart. The large artery at left is the
innominate (unnamed) artery, which quickly branches
into the right common carotid artery, which supplies
the right side of the neck and head, and the right
subclavian artery, which supplies the right arm. The
vessel in the centre is the left common carotid artery,
supplying the left side of the neck and head. The vessel
on the right is the left subclavian artery. Like trees,
arteries divide into smaller and smaller branches. All
the body's arteries, with the exception of those in the
lungs, arise from the aorta (see also page 62).
Coloured angiogram (arteriogram). Jean-Claude Revy

Above
THE INTERIOR OF THE ARTERIES, showing
two main channels. The artery at right
can be seen to divide into two.
Endoscopic image. Manfred Kage

THE HEART, shown in a cross-section through the chest. At centre right is the heart (*pink*). The descending aorta is shown lower centre (*circular pink*). At each side are the lung fields (*black*). A cross-section of a thoracic vertebra of the spine (*blue*) appears below the aorta; circling the lungs are rib bones (*blue*) (see also pages 60 and 61). Coloured computed tomogram

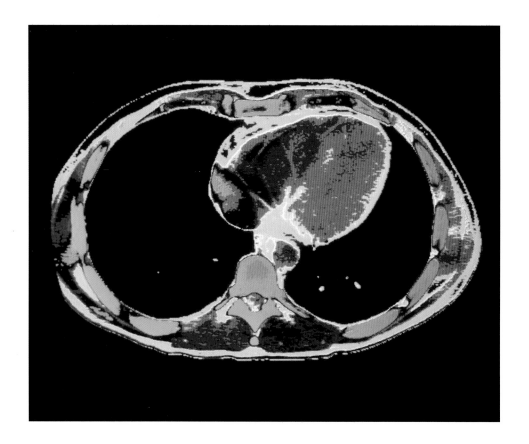

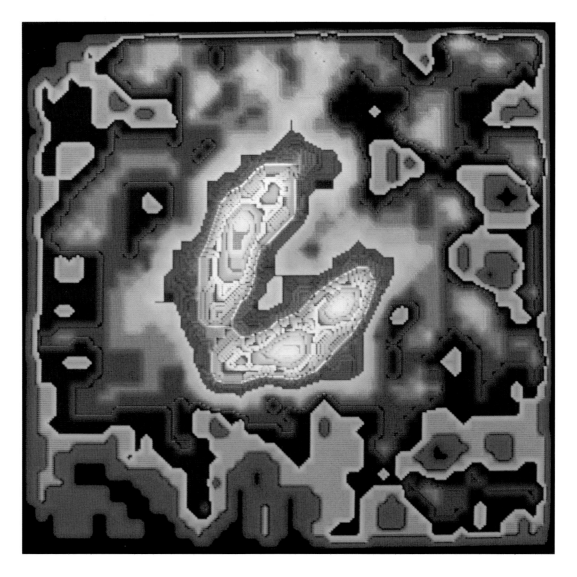

THE HEART. The central horse-shoe shape is the muscle of the left ventricle of the heart. The left ventricle is the largest chamber of the heart, with the thickest muscular wall. When it contracts, it pumps blood to the rest of the body – the right ventricle pumps only to the lungs, which are nearby. When investigating after a heart attack, this is the muscle which is scanned, since it is possible to tell from its condition how much tissue has died. The heart shown here can be seen to be a healthy one, since the horse-shoe shape is continuous; after a heart attack, the shape would be broken up. Coloured gamma camera scan or scintigram

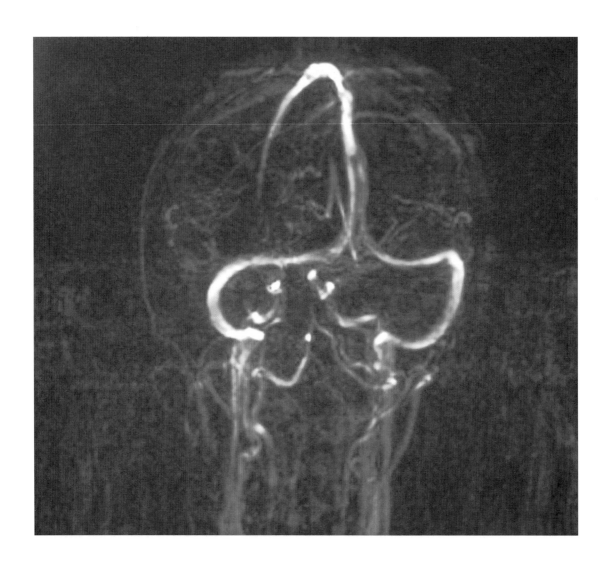

BLOOD SUPPLY to the brain of a 16-year-old boy. The outline of the boy's head, viewed from the back, is just visible in this image. The spine can also be seen *centre bottom*. Blood vessels run up the neck at *left* and *right*. At the top of the head, blood vessels run between the two hemispheres of the brain, before splitting up and arching around the cerebellum. Magnetic resonance image. Simon Fraser

BLOOD CELLS. This image shows red blood cells (erythrocytes) and a single white blood cell (leucocyte) (*bottom left*). These are the two main cellular components of blood. Red blood cells carry oxygen and carbon dioxide, their biconcave shape providing maximum surface area for the exchange of gases. White blood cells are involved in immunological defence mechanisms which protect the body against the invasion of foreign pathogens in the blood and lymph system. They also play a part in antibody production (see also pages 98, 100, 105, 106). Coloured scanning electron micrograph. *Magnification: x 1350*. K.R. Porter

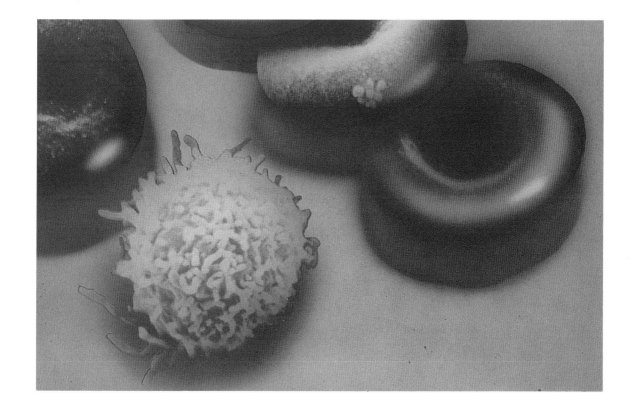

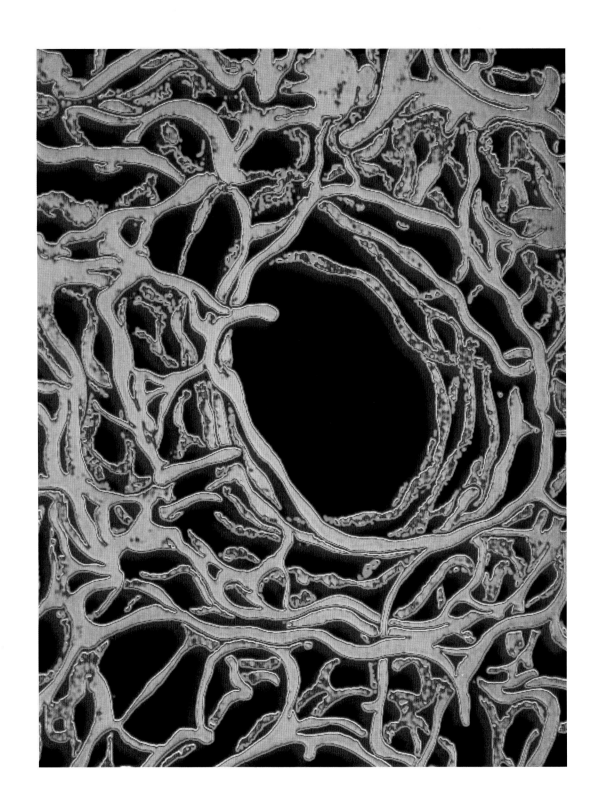

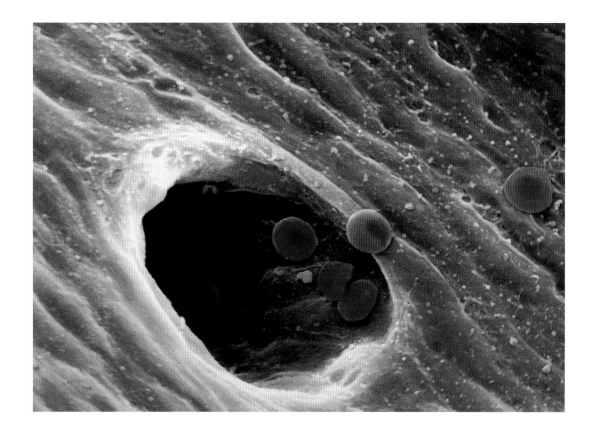

Opposite
THE SPLEEN, in section, showing the fine network of fibres known as trabeculae which form a framework within which the functions of this organ take place. The spleen is part of the lymphatic system and is involved in processing white blood cells. It also regulates the number of red blood cells in circulation in the bloodstream. Coloured scanning electron micrograph.
Magnification: x 9880. Alfred Pasieka

Above
BLOOD CELLS. Here a group of red blood cells are seen travelling from a large vessel into a small capillary. During its short life of about four months, a red blood cell covers approximately 15 km (9 miles) a day for a total of 1500 km (900 miles). In a litre of blood there are normally 5000 billion red blood cells. They transport oxygen from the lungs to the tissues. The carbon dioxide produced in these processes is returned to the lungs, where it is exhaled. Coloured scanning electron micrograph.
Magnification: x 1800. Professor Pietro Motta

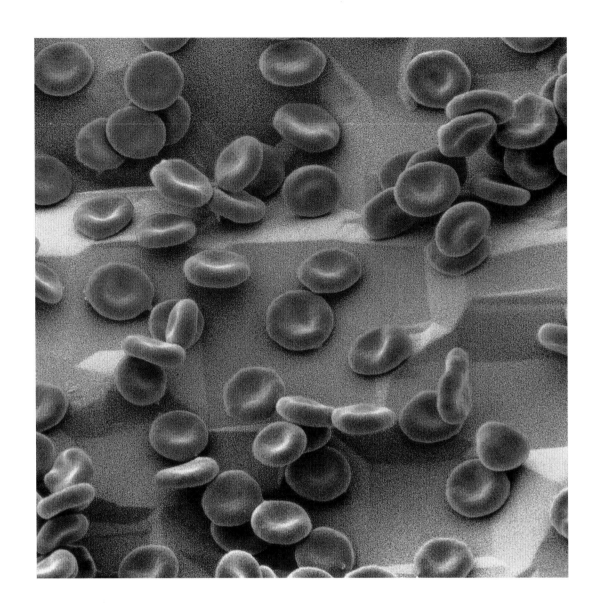

BLOOD CELLS. Mature red blood cells, biconcave in shape, have no nucleus and their cytoplasm is packed with haemoglobin, a red pigment by which oxygen is transported around the body. Coloured scanning electron micrograph. David Scharf

A BLOOD CAPILLARY, seen in transverse section.
A single red blood cell is shown in the centre. Here
the normally biconcave cell has become distorted,
in order to enter a small capillary. Capillaries range
in diameter from 3 to 10 micrometres – the smallest
are half the diameter of red cells. There is a 65,000-
km (40,000-mile) network of capillaries in the body.
Coloured transmission electron micrograph.
Magnification: x 7070

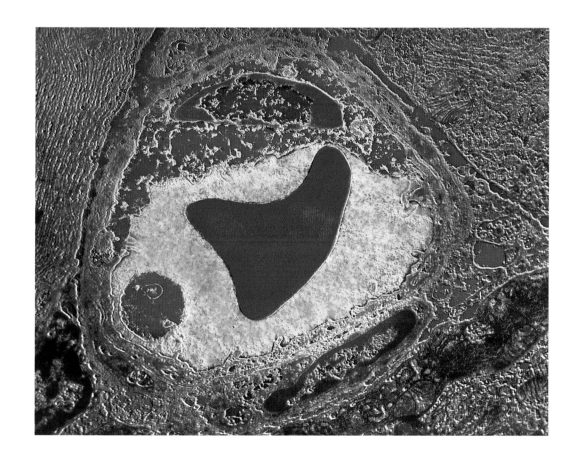

Rémy Fenzy, Untitled, 1991.
Selenium-toned gelatin silver print

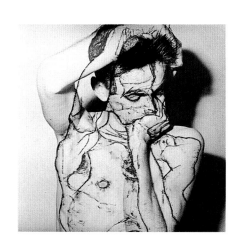

4

THROUGHPUT

THE BODY'S DIGESTIVE
AND EXCRETORY SYSTEMS

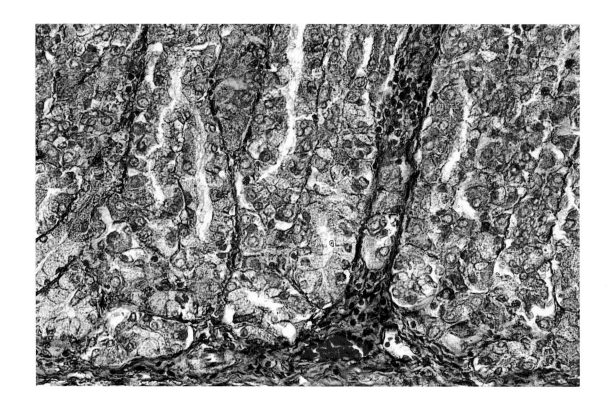

Above and opposite
STOMACH LINING. The images *above and opposite* show the lining of the stomach, the gastric mucosa. The surface of this is covered with gastric pits (*above, green*), in which gastric glands are found. These produce about 3 litres (5 pints) of gastric juice daily. A thick coat of mucus prevents the gastric juice from digesting itself. The wide diameter of the pits shown *opposite* (*black*) suggests that they were active and secreting when the image was made. *Above* Light micrograph. *Magnification: x 414.* Astrid and Hanns-Frieder Michler. *Opposite* Coloured scanning electron micrograph. *Magnification: x 125.* Professor Pietro Motta

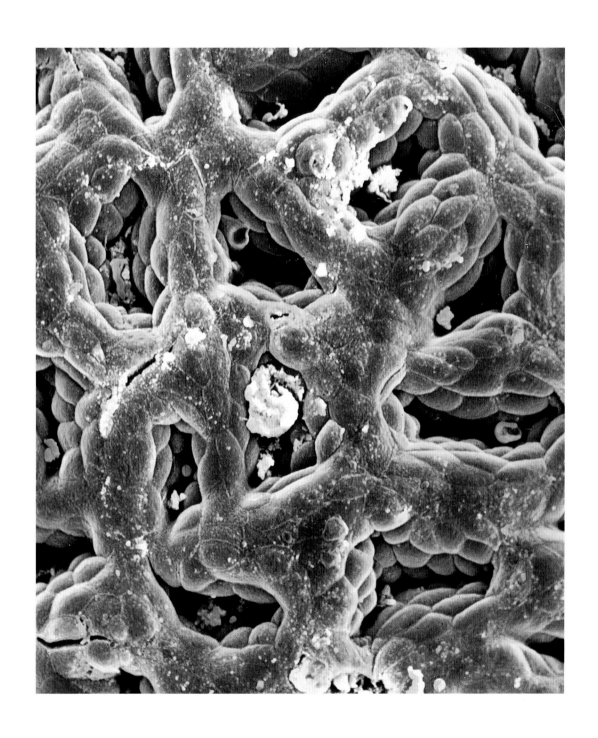

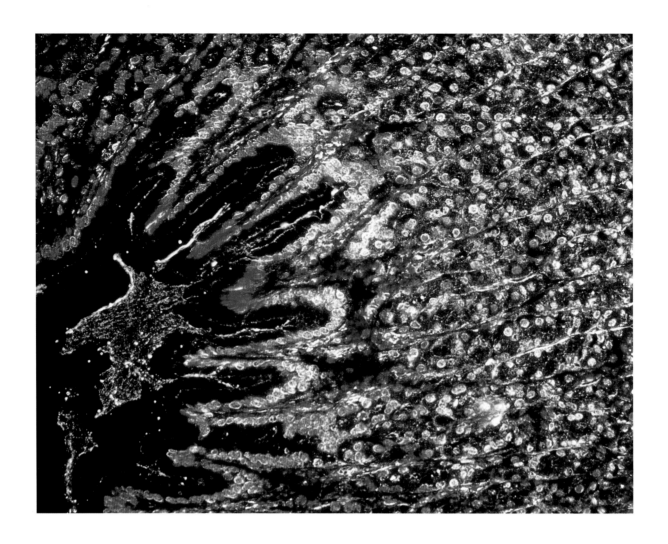

THE STOMACH, in section. This image shows part of the
digestive tract which functions in the production of
gastric juice, a watery mixture of hydrochloric acid, the
digestive enzyme pepsin, and hormones. The inner layer,
the mucosa, may appear folded when the stomach is
empty. Such folds are called rugae and they disappear
when the stomach is full. Light micrograph.
Magnification: x 1340. Manfred Kage

THE DUODENUM. The small intestine is about 6 metres (20 foot) long and is divided into three sections: the duodenum, the jejunum and the ileum. The wall of the duodenum has many tiny folds, known as villi, which project 0.5 to 1 mm out into the intestinal cavity. These folds greatly increase the absorptive and secretory surface of the mucous membrane which lines the small intestine. Coloured scanning electron micrograph. *Magnification: x 25*. David Scharf

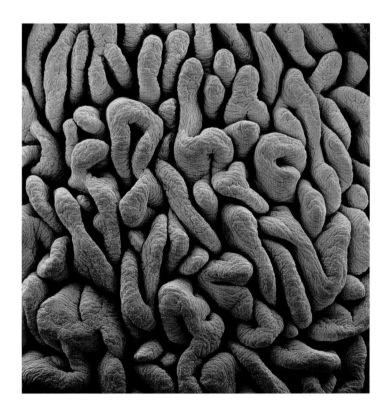

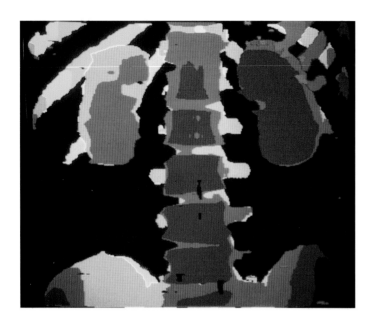

Above
THE KIDNEYS. The kidneys (*top right and left*) are situated just above the waist on either side of the spinal column (*red, at centre*). They are responsible for filtering the blood and excreting waste products and excess water in the form of urine. In this image a few ribs can be seen at the top and part of the pelvis at the bottom. Coloured computed tomogram

Opposite
THE KIDNEYS. This image of the abdominal area shows the drainage of urine from both kidneys down the ureters towards the bladder. The spine is visible at the centre. In the top area, at *left* and *right*, the branches of the renal pelvis (the major collecting area for urine) and the tube-like ureters can be seen. The ureters are the small, finger-like projections (*orange and purple*), hanging downwards. In fact these run right down both sides, but they are obscured here by the way in which the image has been coloured. The bladder occupies the centre part of the bottom of the image. A kidney is about the size of a cupped hand. Coloured normal intravenous urogram

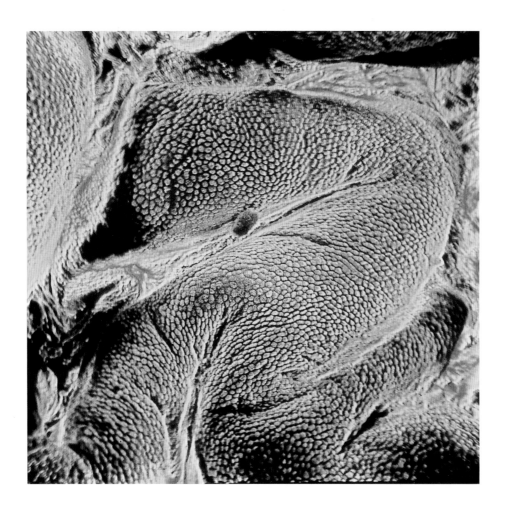

Above
THE LINING OF THE BILE DUCT. Bile is a thick alkaline fluid produced by the liver and stored in the gall bladder. It is then drained via the bile duct into the duodenum, where it is needed for the digestion of fat. About half a litre (one pint) of bile is produced every day. Coloured scanning electron micrograph. *Magnification: x 50*

Opposite top and bottom
THE GALL BLADDER. The mucous layer within the gall bladder is elevated into tiny folds, called rugae, which give it a honeycombed appearance. The gall bladder functions as a storage sack for bile. The fact that the wall of the gall bladder is folded increases the area which comes in contact with bile, allowing the gall bladder to absorb and concentrate as much bile as possible.
Top: Coloured scanning electron micrograph. *Magnification: x 182*. Professor Pietro Motta. *Bottom*: Coloured scanning electron micrograph. *Magnification: x 240*. Professors Pietro Motta and A. Caggiati

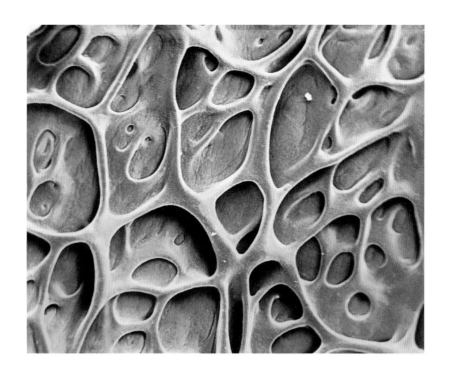

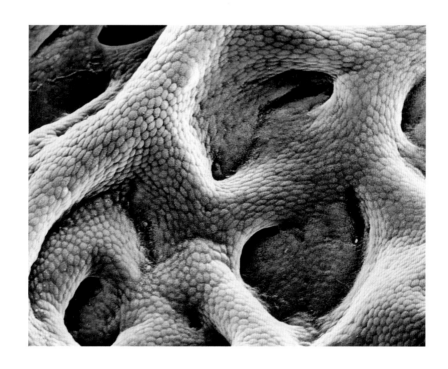

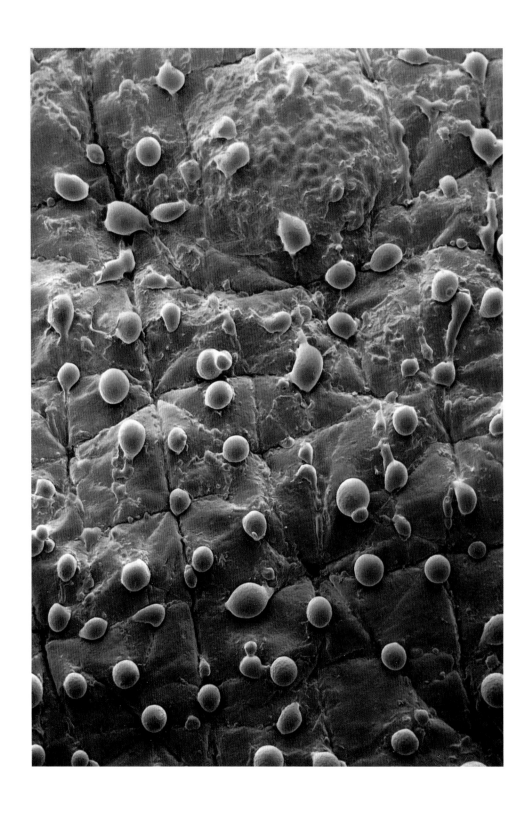

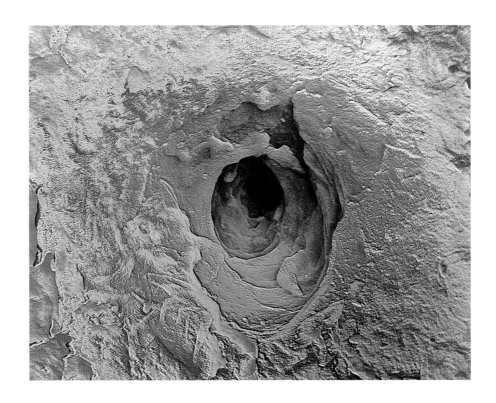

Opposite
SWEAT. In this image, droplets of sweat (*blue*) can be seen on the surface of the skin on the back of a hand. These are emerging from the entrance of the many sweat glands that lie in the dermis of the skin. The sweat shown here has appeared after one hour of exercise. Secretion of sweat is a method of controlling body temperature. One quarter of the body's heat loss comes about by sweating. Coloured scanning electron micrograph. *Magnification: x 40*. Richard Wehr

Above
A SWEAT PORE. This crater-like shape is a sweat pore in the skin obtained from a blister on the palm of a man's hand. The skin on human palms is arranged in ridges, with sweat pores appearing as miniature depressions tunnelling into them. The palm of the hand is one of the areas of the body that is richest in sweat glands. Coloured scanning electron micrograph. *Magnification: x 430*. Dr Jeremy Burgess

Helen Chadwick, *Self-portrait*, 1993.
Cibachrome transparency, glass, aluminium,
electric apparatus

5
CONTROLS

THE BRAIN AND THE BODY'S
NERVOUS SYSTEM

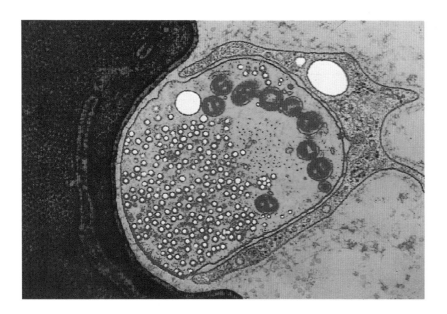

Above
JUMPING THE NERVE-MUSCLE GAP. This image shows a neuromuscular synapse – the junction, or gap, between a nerve fibre and a muscle fibre. At centre is the end of the nerve (*blue*), closely associated with the muscle fibre (*left*, *red*). The small dots in the nerve end are vesicles. These contain a neurotransmitter which, when the nerve is activated, crosses the gap and activates the muscle. The *green* is a Schwann cell, which forms a kind of insulation tape around the nerve (see also pages 89 and 95). Coloured transmission electron micrograph. *Magnification: x 29,690*. Dr Don Fawcett

Opposite
THE CEREBELLUM, the posterior part of the brain. The cerebellum is situated immediately above the nape of the neck. It coordinates fine movement, posture and balance.
The surface of the cerebellum is folded; here the exterior space (*white*) is clear and unstained, but contains sectioned blood vessels (*deep red*). The cortex of the cerebellum is divided into an outer molecular layer (*smooth orange stain*) containing nerve fibres and an inner granular layer of nerve cells (*pale, granular stain*). At the junction of these two layers are the bodies of Purkinje cells, whose dendrites (processes) extend into the molecular layer. The branching dark tissue arising at *bottom right* is the medulla, where the spinal cord continues into the skull. The medulla consists of bundles of nerve fibres. Light micrograph. *Magnification: x 25*. Manfred Kage

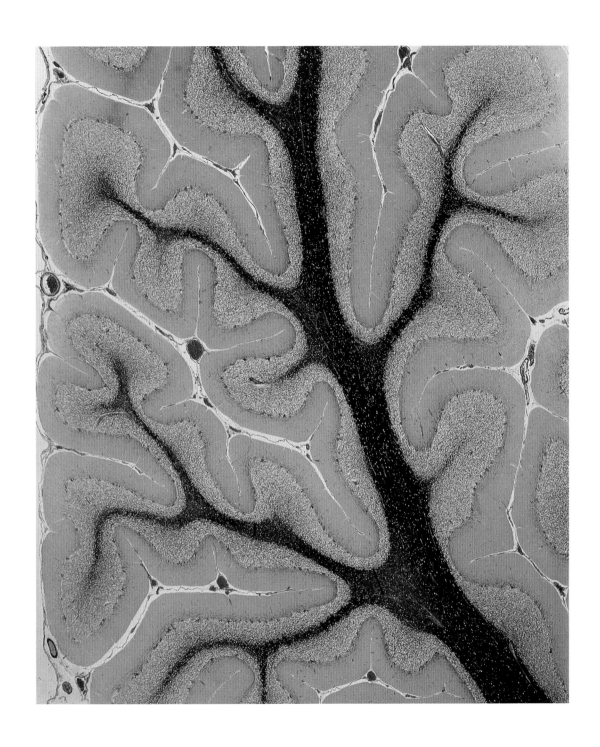

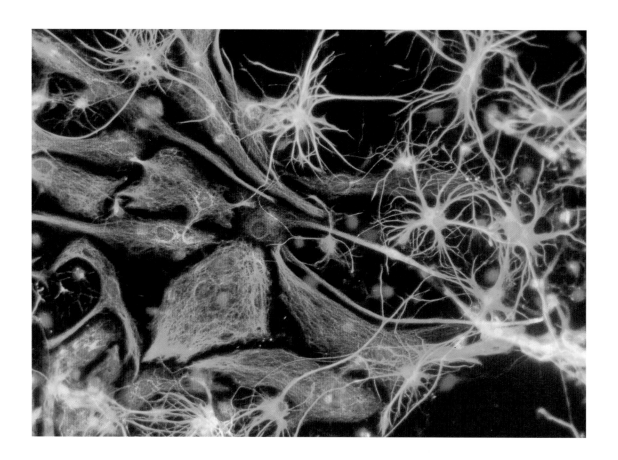

THE BRAIN'S 'NERVE GLUE'. These neuroglial precursor cells, cultured in the laboratory, constitute the non-conducting special connective tissue in the brain known as neuroglia ('nerve glue'). The star-shaped astrocytes (*light green*) supply nerve cells with nutrients and may store nerve information. They are the most common type of neuroglial cell. Cell nuclei are stained *blue* (see also page 91). Immunofluorescent light micrograph. *Magnification: x 960*. Nancy Kedersha

Opposite
CONTROLLING THE MUSCLES. This image shows the junctions, or synapses, between motor nerve fibres (*yellow*) and skeletal muscle fibres (*magenta*) (see also pages 86 and 95). Coloured scanning electron micrograph. Dr Don Fawcett

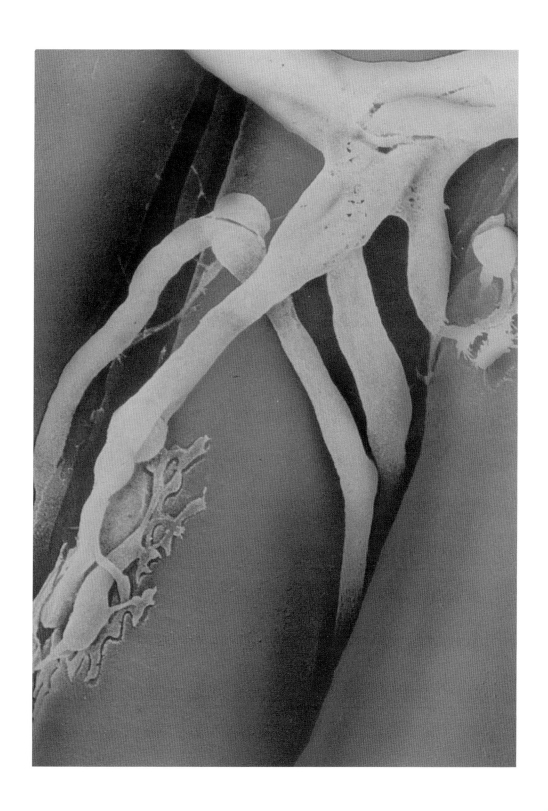

Opposite
NERVE CELLS, or neurons, in the brain. Each neuron consists of
a cell body (*green*) containing a nucleus and cytoplasm, and
branching processes extending from it. There are two types of
branching processes: axons and dendrites. A single, thicker axon
extends from each cell body (as at *bottom left*); it transmits
nerve impulses away from the cell body. Incoming impulses are
received by the many highly branching dendrites, which act as
sensory receptors for the cell. In this way each neuron receives
stimuli, processes it in the cell body, and transmits a response.
Neurons exist in varying shapes and sizes throughout the
nervous system, but all have this basic structure.
Coloured scanning electron micrograph. David Phillips

Above
INSIDE THE BRAIN'S 'NERVE GLUE'. This image shows an
oligodendrocyte (*beige*) attached to the surface of a nerve cell
(*blue*). Oligodendrocytes are components of the neuroglia, the
network of spidery cells that supports the nerve cells (see also
page 88). Transmission electron micrograph. Alain Privat

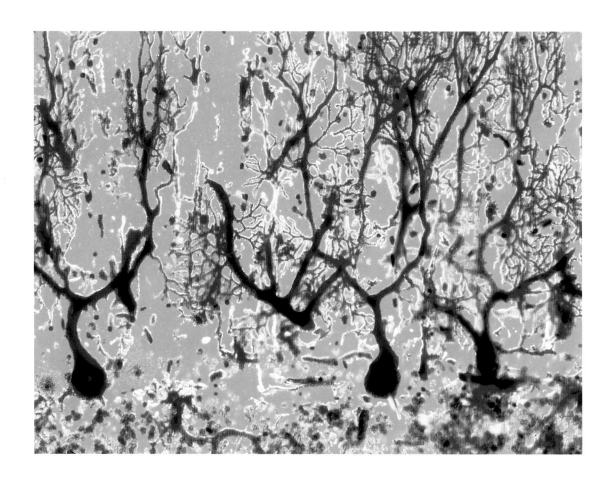

THE BRAIN. In this brain tissue, shown in cross-section, the flask-shaped cells *at bottom* are Purkinje nerve cells. Arranged in a single layer, they are among the largest neurons in the body. From the outer end of each cell dendrites can be seen, branching out. These receive electrical signals from other nerve cells (see also page 90). Purkinje cells are named after their discoverer, the Czech histologist and physiologist Johannes Purkinje (1787–1869). Light micrograph. *Magnification: x 160*. Alfred Pasieka

THE BRAIN'S OWN TRANSMITTERS. Here axons, or nerve fibres (*black*), can be seen running through layers of the cerebrum, the largest part of the brain. Axons are the part of nerve cells which transmit impulses to other areas of the brain or organs of the body. They often form thick bundles of nerves running in parallel; in the cortex of the cerebrum they connect with thousands of other brain cells. The cerebrum is the part of the brain responsible for human consciousness, memory and intellect, and for voluntary activities of the body. Light micrograph. Manfred Kage

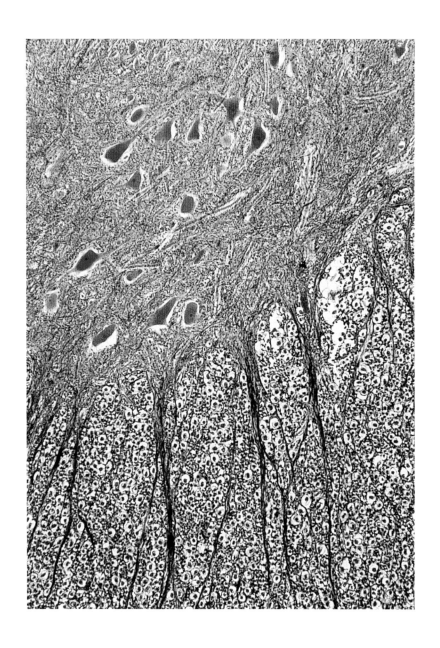

THE SPINAL CORD, in cross-section, showing the junction between the grey matter – the nerve cells (*top*, *orange*) – and the white matter – the conducting fibres (*bottom*) – in the anterior horn, the part of the spinal cord which controls the muscles of the limbs and trunk. The large cells (*red*) are anterior horn cells, whose axons move the impulses away. Each dot shown here is a nerve; thousands are visible in this image. Light micrograph. *Magnification: x 205.* Astrid and Hanns-Frieder Michler

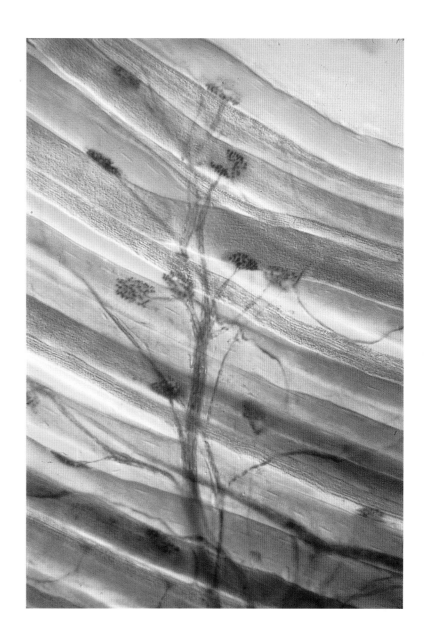

CONTROLLING THE MUSCLES. This image shows synapses between a motor neurone, a nerve cell (*tree-like*), and skeletal muscle cells (*bands in background*). A synapse is the gap between a nerve ending and its target. When a nerve cell is stimulated, the impulse moves to the end of the nerve fibre, which divides to form a cluster of small swellings on the muscle surface (visible here, looking like large leaves on a tree). Chemical transmitters are then released from the nerve ending and these activate or inhibit muscle activity (see also pages 86 and 89). Light micrograph. *Magnification: x 85*. Eric Grave

Javier Vallhonrat, *Sphere*, 1988.
From the series 'The Possessed Space'.
Gelatin silver print with frame

6

DEFENCES

THE BODY'S PROTECTIVE AND IMMUNE SYSTEMS

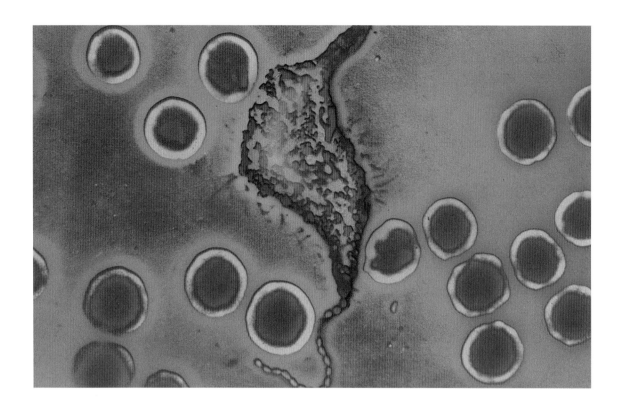

Above
THE BODY FIGHTS BACK. Here a white blood cell is shown engulfing a chain of *Streptococcus* bacteria. The white blood cell (*green*) is seen among circular red blood cells. At *lower centre* it has captured a bead-like string of smaller streptococcal cells (*orange*). White blood cells circulate in the blood and play a role in the immune response, attacking foreign invaders with enzymes or engulfing and digesting them. Coloured light micrograph

Opposite
A CULTURE OF *STREPTOCOCCI* BACTERIA. Most bacteria feed on dead and decaying matter, but some are parasites of humans and animals. Although some of these parasites live harmlessly as part of the normal healthy flora of the respiratory, alimentary and female genital tracts, others are disease-causing (see page 101). Coloured scanning electron micrograph. David Phillips

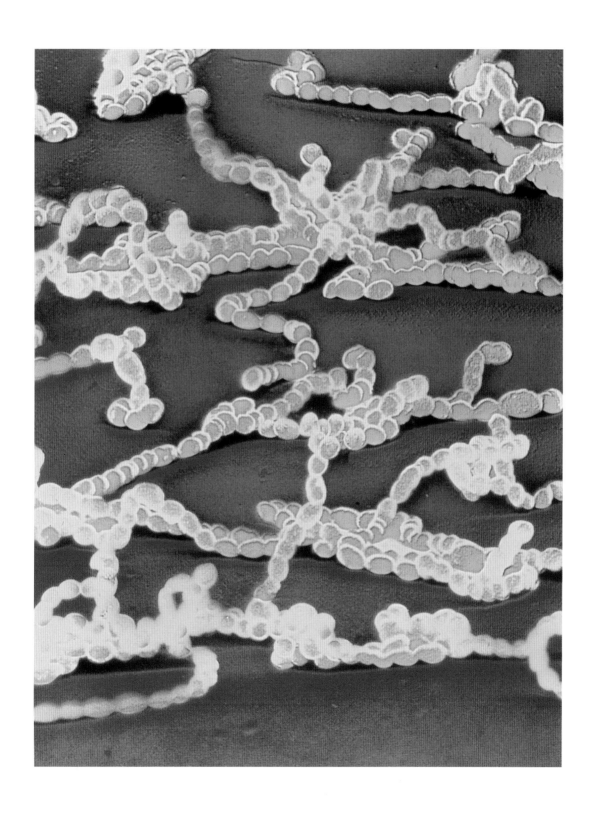

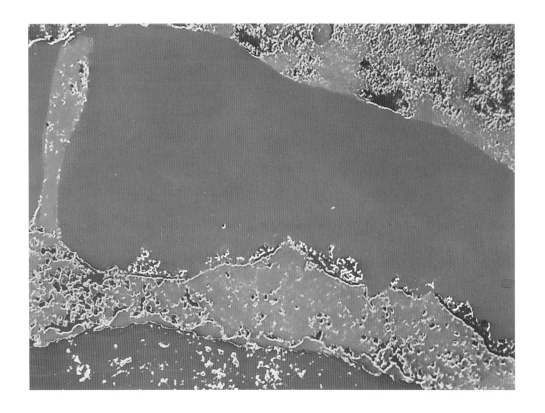

Above
WHITE BLOOD CELL (*bottom*), showing the presence of an HLA (human leucocyte antigen). Two cells are actually visible here (*top and bottom*); the *blue* is the space between them. In the bottom cell, the *orange* is the nucleus and the *green* the cytoplasm. The HLA appears as an uneven, spiky red area on the exterior surface of the cell. HLA is an identifier; it identifies the cell to which it is attached. An antigen is a protein which stimulates the production of an antibody. Coloured transmission electron micrograph. *Magnification: x 36,080*

Opposite
THE SORE THROAT MICROBE. Here the bacterium *Streptococcus pyogenes* is shown forming its typical chain, like a string of beads (see also page 99). This microbe is carried in the mouth and throat by about one person in ten. Disease-causing strains of *Streptococcus pyogenes* are responsible for some skin infections, including impetigo; for scarlet fever, and also for the high incidence of sore throats and tonsillitis ('strep throat') in young children. Coloured scanning electron micrograph. *Magnification: x 20,020*. Alfred Pasieka

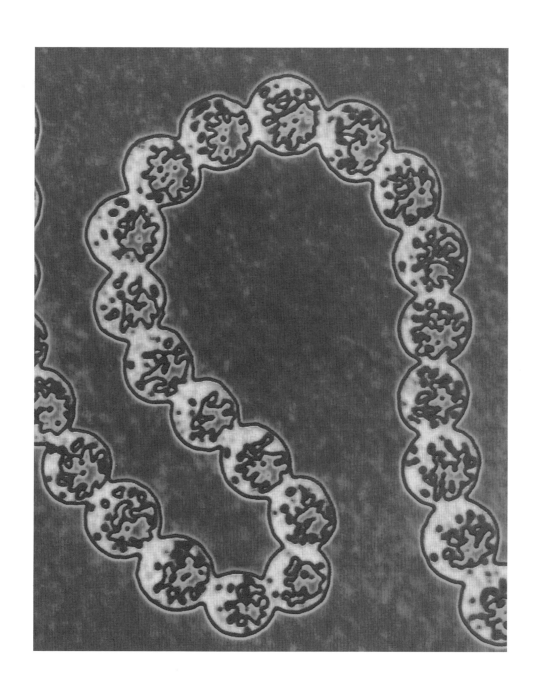

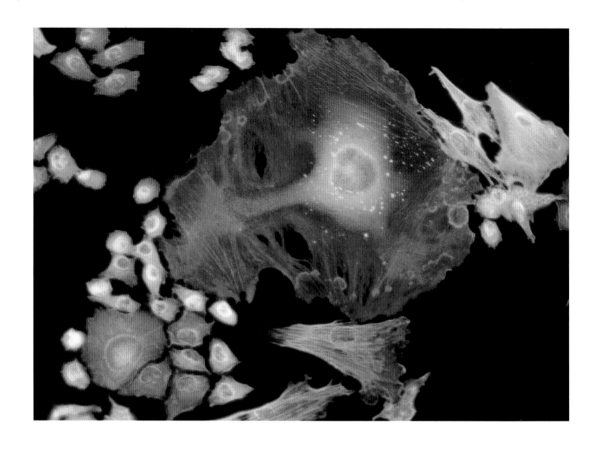

SUPPORT AND REPAIR SERVICE. Fibroblast cells, cultured among
skin cancer cells recovered from a tumour. A cell is a blob of jelly,
called cytoplasm, with a dense centre, known as the nucleus.
Fibroblasts are cells which form connective tissue in support of
other cells or in places where tissue has been damaged. A large
fibroblast can be seen *right centre*: the nucleus is coloured *blue*
and the cytoplasm *orange*. It is surrounded by actin fibres (*green*)
which have formed around the fibroblasts in the culture dish, and
by other fibroblast cells. The small cells at *left* are the skin cancer
(see also page 48). Immunofluorescent light micrograph.
Magnification: x 920. Nancy Kedersha

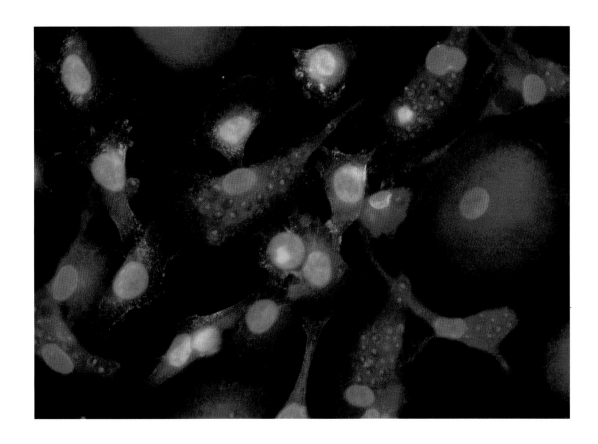

SUPPORTIVE SCAVENGERS. Macrophages are shown here ingesting yeast in a cell culture also containing skin cancer cells. Macrophages are large white blood cells which roam the blood and tissues scavenging for foreign, harmful invaders and for dead cells. Here macrophages from the lung (*red*) have 'eaten' infective yeast cells, shown as dots. The melanoma cancer cells (*light green*) may also be a target for the macrophages. Cell nuclei are coloured *blue*. Immunofluorescent light micrograph. *Magnification: x 1840*. Nancy Kedersha

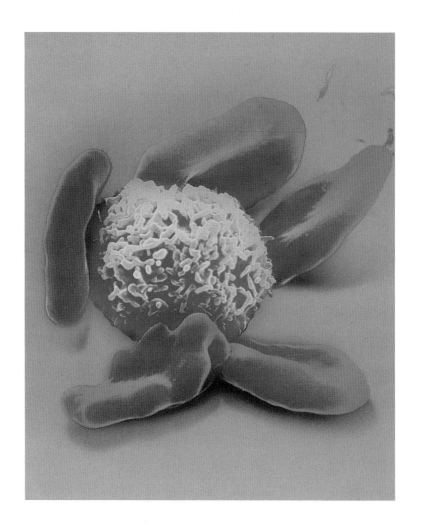

PROTECTIVE DESTRUCTION. A macrophage
(*blue*) is shown surrounded by red blood cells.
This cell-cluster arrangement is called 'rosetting'.
The macrophage is about to engulf and consume
these cells, in a process known as phagocytosis.
Red blood cells are incapable of repairing
themselves. They live an average of 120 days
and are then 'eaten' by macrophages. These red
blood cells are so old that they have lost their
biconcave shape (compare with page 65).
Coloured scanning electron micrograph.
David Phillips

A CULTURED WHITE BLOOD CELL (*blue*) engulfing a yeast cell (*green*). The white blood cell is reaching out towards the yeast spore with projections of its cytoplasm. Eventually it will swallow it up and digest it. White blood cells play an essential role in the immune response: they collect at sites of infection and either consume foreign invaders or, more commonly, attack them with enzymes. The yeast cell shown here is similar to the fungus that causes thrush. Coloured scanning electron micrograph

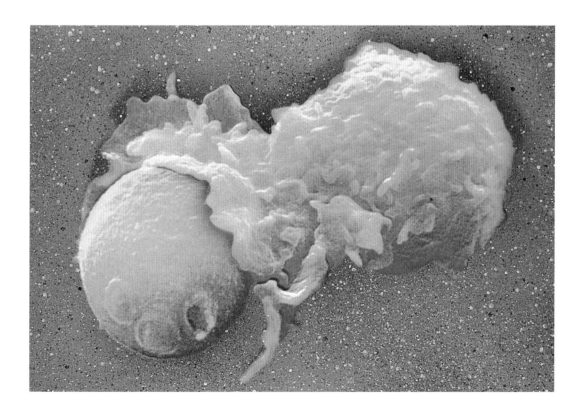

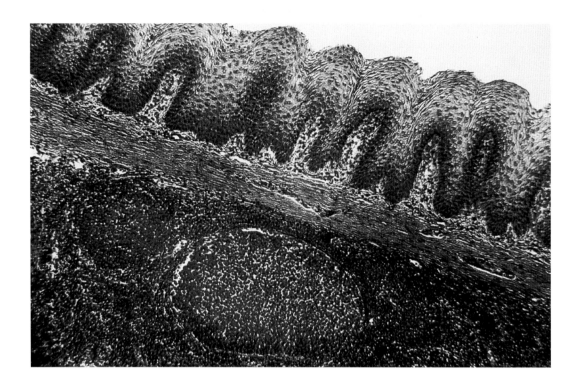

Above
A TONSIL, in section. The palatine tonsils are situated on each side at the back of the mouth. They consist of the epithelium – the surface (*pink*) – a collagen fibre (*blue*) and lymphoid tissue (*red*). The lymphoid tissue contains white blood cells, which protect against infection. Light micrograph.
Magnification: x 150. Ken Eward

Opposite
A BLOOD CLOT, or thrombus. Red blood cells (*orange*) have been trapped behind a web of fibrin (*green*), a substance which is produced when a blood vessel is injured and which slows down blood flow to form a clot. Blood clots may occur on the surface of skin, when it is injured, or inside blood vessels. A clot inside a blood vessel is known as a thrombus and may lead to a heart attack if it blocks a heart artery. Coloured scanning electron micrograph.
Magnification: x 4750. David Phillips

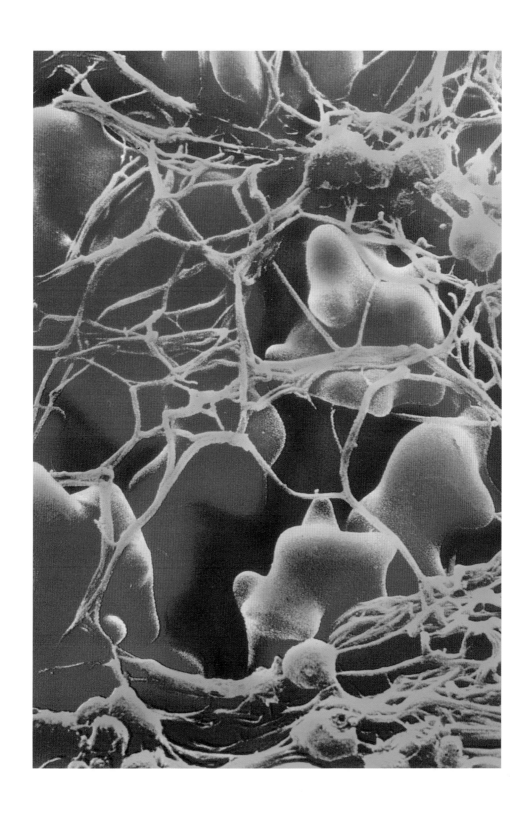

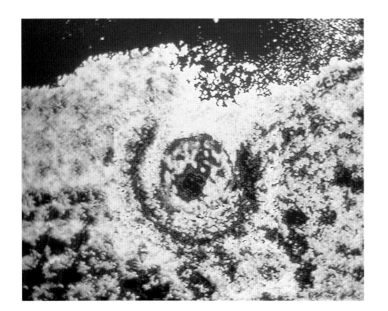

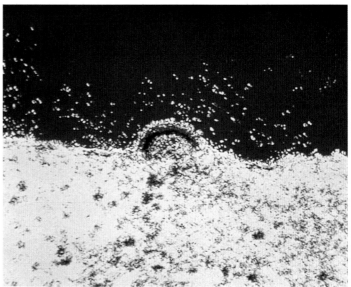

HIV: HUMAN IMMUNODEFICIENCY VIRUS. The image *above left* shows an HIV virus (*at centre*, *red*) penetrating and infecting a T-lymphocyte cell. The T-lymphocyte is a key cell of the human immune system.

It develops inside the thymus gland and attacks infected cells with proteins called lymphokines. HIV viruses, which cause AIDS, attach to the external membrane of T-cells and inject strands of RNA (ribonucleic acid –

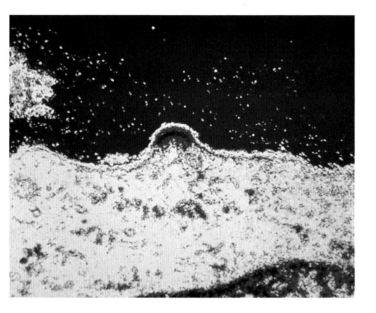 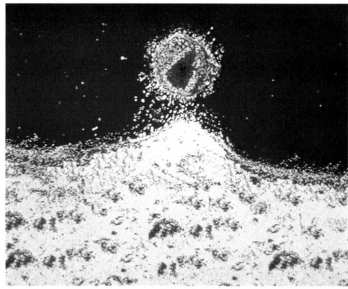

their genetic material) into the cytoplasm. Using the cell's resources, the RNA strands replicate and new HIV viruses are formed. The new copies of the virus then leave the cell (*see remaining 3 pictures*), budding from it and damaging the cell membrane. The infected T-cell dies and the response of the immune system to infections is severely diminished.
Coloured transmission electron micrographs

Jo Brunenberg, *Dei nervi dell' uomo*, 1989. From
the series 'Immagini scoperte/Discovered Images'.
Selenium-toned silver print

7

REPLICATION

CELL DIVISION AND
SEXUAL REPRODUCTION

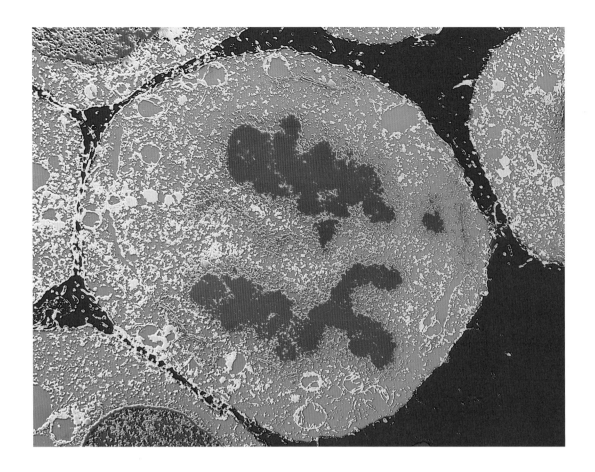

CELL DIVISION. Here a HeLa cell is being reproduced by the process of mitosis – the copying process by which a cell nucleus produces two daughter cells which are genetically identical to the parent cell. At upper and lower centre are two sets of chromosomes (*orange*). Each of the two new cells will therefore have all the properties of the original cell. HeLa cells are named after Henrietta Lacks, a 30-year-old American woman who in February 1951 had a sample of cancerous cells taken from her cervix. These were left to grow in a culture dish, where they multiplied rapidly. They proved so hardy that they even survived being spilled. These cells have been carried, deliberately or accidentally, from lab to lab, and have been used for many experiments in the cause of cancer research. Henrietta Lacks died in October 1951. Coloured transmission electron micrograph. *Magnification: x 5570.* Dr Gopal Murti

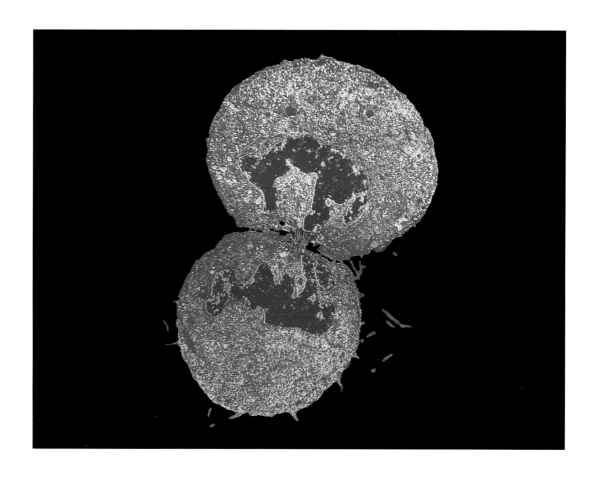

CELL DIVISION. An embryonic kidney cell is shown here going through the process of division. This is a late stage of mitosis: the nucleus (*red*) has already split in two. The cytoplasm (*blue*) is now being divided and the cell is about to break into two complete, genetically identical, daughter cells. Coloured transmission electron micrograph. *Magnification: x 3400.* Dr Gopal Murti

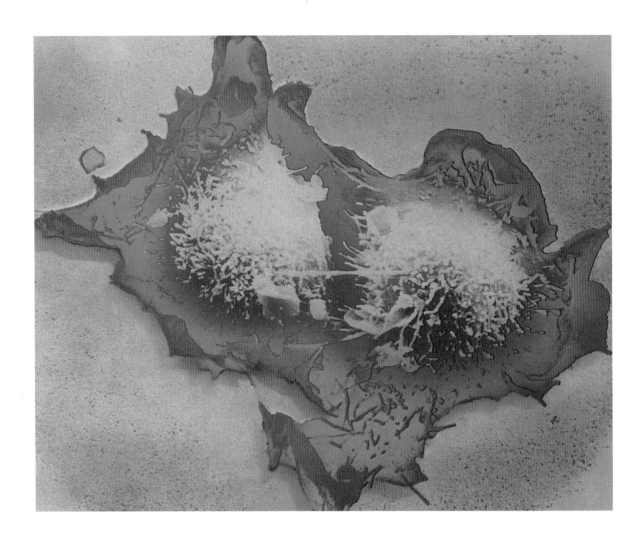

CELL DIVISION. Here two daughter cells (*yellow*) are emerging from the last stage of cell division. The chromosomes have already been duplicated and distributed to the daughter cells but the cells are still connected by a narrow cytoplasmic bridge of threads. The long filaments that protrude from the surface of each cell provide mechanical support and supply nutrients. Coloured scanning electron micrograph. K.R. Porter

CHROMOSOMES. Chromosomes are the thread-like DNA structures of the cell nucleus which carry genetic information. Each chromosome consists of two strands joined together in a region known as the centromere. Chromosomes are capable of constructing exact copies of themselves while the cell is in the resting stage between successive divisions. When division occurs, the centromere splits lengthwise. The nucleus of every human cell contains 46 chromosomes, 23 of maternal and 23 of paternal origin. Coloured scanning electron micrograph

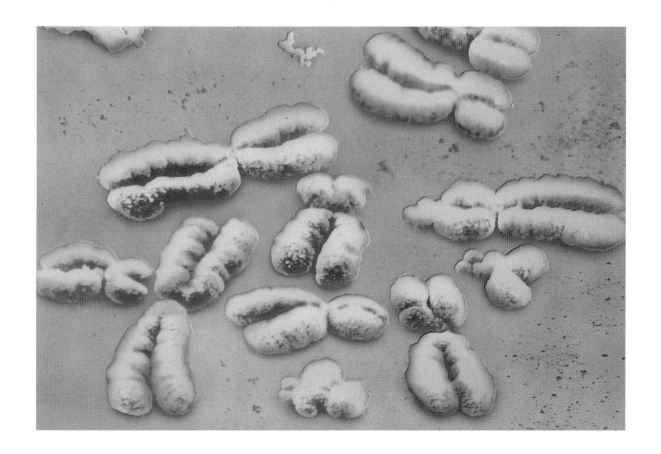

Below

THE SPERM STORE. The epididymis is a coiled tube that connects the testicle to the vas deferens. Sperm mature in this tube for between 1 to 3 weeks, before they are either ejaculated or absorbed back into the body. The epididymis, which is about 7 metres (23 feet) long, is seen here in various planes of section. The *white* spaces contain closely packed sperm, stained *red*. Light micrograph. *Magnification: x 210.* Astrid and Hanns-Frieder Michler

Opposite

THE LINING OF THE OVIDUCT, at mid-cycle. The oviduct is the channel which conducts the ovum (egg) from the ovary, where it is formed, to the uterus, where the fertilized egg develops into an embryo. There are two types of cell present in the lining: ciliated and secretory. The cilia are the longer projections. The secretory cells have shorter projections called microvilli which are responsible for lubricating the environment.

Coloured scanning electron micrograph. Dr Don Fawcett

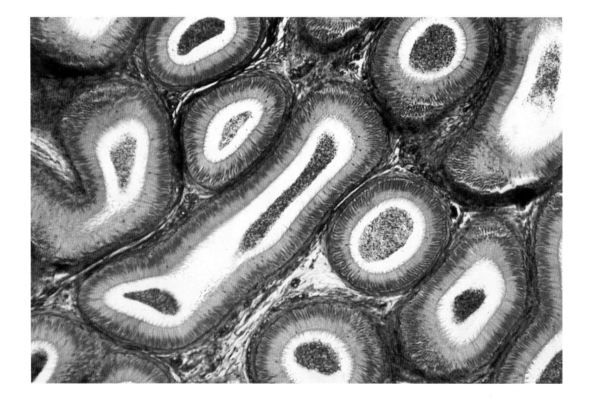

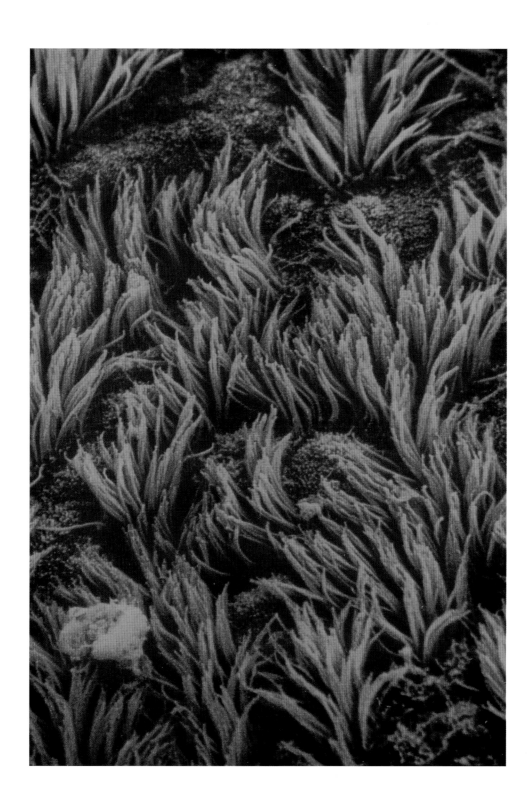

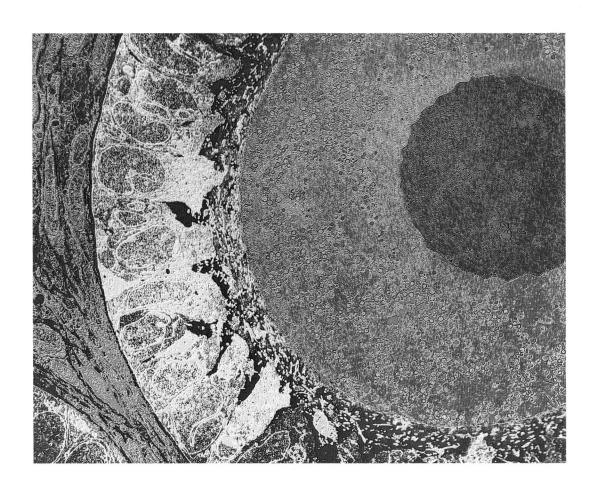

AN EGG CELL, at an early stage of its development, when it is known as a primary oocyte. It is composed of a nucleus (*red, top right*) and cytoplasm (*pink*). The *zona pellucida*, the membrane that surrounds it, is coloured *blue and yellow*. Coloured transmission electron micrograph. *Magnification: x 3440*. Professor Pietro Motta

A SPERM, displaying its entire head, neck and tail. The green head contains a nucleus housing the 23 chromosomes of the male gamete. The head is capped with enzymes which help the sperm to penetrate the egg during fertilization. The tail is the sperm's propulsion unit; it is powered by mitochondria — cell components which generate energy. These are coloured *pink* in the upper part of the tail. Coloured transmission electron micrograph. *Magnification: x 10,580*. Dr Tony Brain

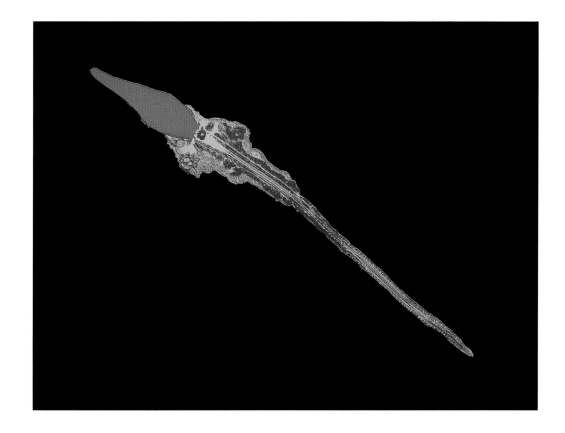

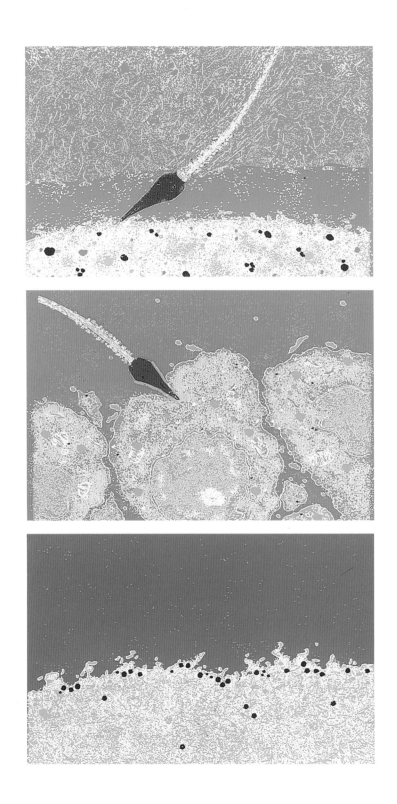

Opposite, top to bottom
FERTILIZATION. In the top image a sperm has just penetrated the *zona pellucida*, the thick membrane (*at top*) that surrounds the mature ovum (egg). The middle image shows the sperm beginning to penetrate the *corona radiata*, the layers of follicular cells around the ovum. The last image shows the ovum after its penetration by a single sperm. At this point, rapid chemical changes take place in the membrane surrounding the ovum to prevent the entry of competing sperm. Coloured transmission electron micrographs. *Magnification: x 2570*

Above
FERTILIZATION. The ovum is seen *at centre*, surrounded by sperm with tails. The human female usually produces one large egg. The male releases some 300 million sperm, of which only a few hundred survive to encounter the egg in the fallopian tube. Only one sperm can succeed in fertilization. Light micrograph

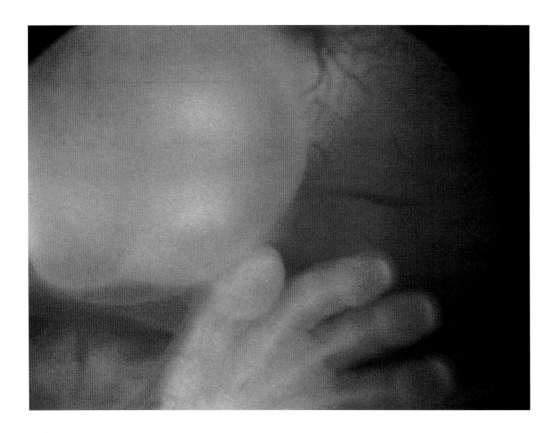

Above
AN EMBRYO. A hand and part of the head of an embryo
at around the seventh week of development. The embryonic
or formative stage of development is considered to be
completed by the eighth week, after which time the unborn
child is known as a fetus. Endoscopic image

Opposite
THE FEMALE BREAST, seen in side view. The breast consists
largely of fibro-fatty tissue (*orange and yellow*). In this tissue
are the milk-secreting glands, from which ducts (*magenta*)
transport the milk to the nipple (*centre left*).
Coloured digitalized magnetic resonance image. John Croyle

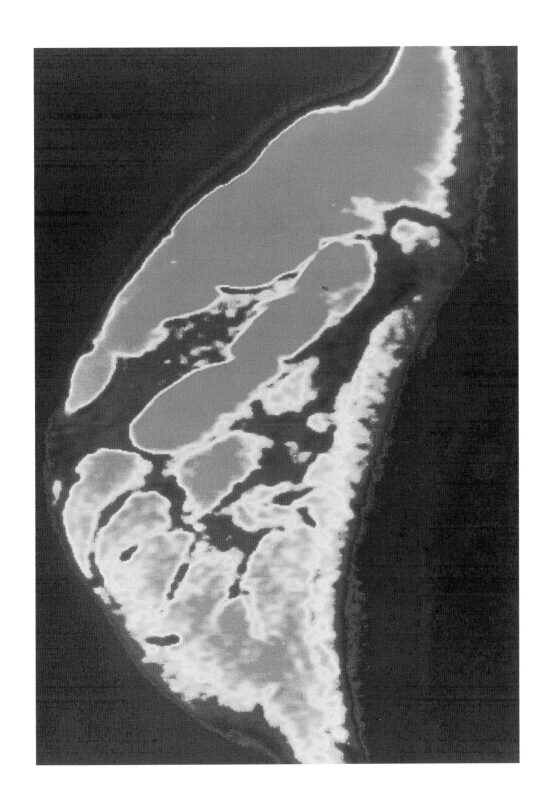

GLOSSARY

Alveolus/alveoli Microscopic air sacs in the lung, attached to ducts which in turn are connected to **bronchioles**. The exchange of oxygen and carbon dioxide takes place in these sacs. There are approximately 30 sacs attached to each duct.

Antibody A blood protein capable of destroying **antigens**, e.g., alien bacteria. Essential for the body's immunity from disease.

Antigens Anything appearing in the body which it interprets as harmful. **Antibodies** are produced to destroy them.

Aorta The main artery leading from the left **ventricle** of the heart. All other arteries stem from the aorta.

Astrocyte One of several types of cell within the central nervous system which make up the **neuroglia**. Its function is to provide nutrients for **neurons.** It may also store information.

Axon A nerve fibre, projecting from the cell body of a **neuron**, which conveys information away from it. Axons divide into several branches, which connect with other nerves or with muscle or gland membranes.

Bronchioles The subdivision within the bronchial tree leading to the **alveoli**. Bronchioles begin at the fifth or sixth **bronchi** and branch up to 20 times more before reaching the terminal and respiratory bronchioles and finally the alveoli.

Bronchus/bronchi The air passages which stem from the windpipe. From two, they divide successively, ending in **bronchioles**.

Cancellous The honeycomb-like structure created by **osteoblasts** during bone development or fracture repair.

Capillary A tiny blood vessel, the wall of which is only one cell thick. Networks of capillaries function to exchange gases and liquids between blood and the tissues.

Carotid artery Either of two arteries which supply blood to the head and neck.

Centromere That part of the **chromosome** which connects the two **chromatids** to each other. It splits longitudinally when chromosome division occurs.

Cerebellum The posterior part of the brain situated immediately above the nape of the neck. It coordinates movement, posture and balance.

Cerebrum The largest, most highly developed part of the brain. Its two hemispheres are responsible for the initiation and coordination of the body's voluntary activity and govern the functions of the lower parts of the nervous system.

Chondrocyte A cartilage cell, embedded in a matrix which the cells have synthesized.

Chromatid One of two threadlike strands formed by longitudinal division of a **chromosome** during fetal development.

Chromosome Threadlike **DNA** (Deoxyribonucleic acid) structure found in the cell nucleus which carries genetic information. During cell division, each chromosome creates an exact replica of itself.

Cilium/cilia A hairlike protuberance on certain **epithelial** cells, particularly of the upper respiratory tract where they help to remove dust and other foreign substances.

Cochlea Spiral organ within the **labyrinth** of the ear. It receives and analyses sound.

Collagen A protein that is the prime constituent of **connective tissue**, but is also found in the skin, bones, cartilage and ligaments. It has great tensile strength.

Compact bone Concentric layers of bony tissue creating the hard, outer layer of bones.

Connective tissue Tissue found throughout the body. It supports, binds or separates more specialized tissues and organs.

Corona radiata The layer of **follicle** cells which encircle a newly ovulated **ovum**.

Cortex The outer part of an organ. It is covered by a capsule or outer membrane.

Corti (Organ of) A sensory organ within the inner ear containing numerous hair cells which convert sound into nerve impulses which travel to the brain via the cochlear nerve.

Cytoplasm The basic substance of the cell which surrounds the **nucleus**.

Dendrite A short branching process of a **neuron** which carries nerve impulses from other neurons into its cell body.

Dermis The thick layer of skin lying below the **epidermis** or outer layer. It is made up of **connective tissue**, **capillaries**, lymph vessels, nerve endings, sweat and **sebaceous glands**, hair **follicles** and muscle fibres.

DNA (Deoxyribonucleic acid). The genetic material of nearly all living organisms. It controls heredity and is found within the nucleus of the cell.

Duodenum The first part of the three-part small intestine. It receives pancreatic juice and bile, and uses its own glands to secrete a protective alkaline juice.

Embryo The human being in the uterus up to the eighth week of development, by which time all major organs are formed.

Enzyme A protein which acts as a catalyst, speeding up a biological reaction. Enzymes are essential for growth and development and also for normal functioning.

Epidermis The outer layer of the skin, itself consisting of four layers. The epidermis constantly renews itself.

Epididymis The tube, connecting the testes to the vas deferens, through which spermatozoa move passively, and in which they are stored until ejaculation.

Epithelial (Adj.) Relating to **Epithelium**.

Epithelium The tissue that covers the external surface of the body and lines its internal hollow structures, excluding blood vessels and lymphatic vessels.

Fibril A very small fibre or a constituent thread of a fibre.

Fibrin The final product of blood coagulation, resulting from the action of an **enzyme**. The fibrous mesh which results seals off the damaged blood vessel.

Fibroblast A cell found throughout **connective tissue** which is vital to the production of **collagen** (protein), elastic and reticular (non-elastic) fibres. These fibres form a network of support around blood vessels, muscle fibres, glands and nerves.

Fibronectin A **glycoprotein** found concentrated in **connective tissue** and the lining of the **capillaries**. It functions as a defence mechanism.

Filiform Having the shape of a thread.

Follicle A small secretory gland.

Follicular (Adj.) Relating to **Follicle**.

Fovea Anatomically, a small depression, most notably in the retina of the eye. It is the centre of greatest acuity, registering form and colour.

Gamete A mature sex cell, whether the female **ovum** or the male spermatozoon.

Germinal (Adj.) Describing the early developmental stages of the embryo.

Glycoprotein A compound made up of protein combined with a carbohydrate. Examples are some **enzymes** and **antigens**.

Haemoglobin The substance within red blood cells, responsible for their colour, which transports oxygen throughout the body.

Haversian (Adj.) Relating to **Canal**: one of the tiny canals which ramify throughout compact bone; **System**: a cylindrical unit of compact bone, comprising a central canal around which are alternate rings of bone matrix, the substance containing bone cells.

Hyaline The most common type of cartilage in the body, an elastic material in which **collagen fibrils** are embedded.

Ileum The lowest part of the three-sectioned small intestine, positioned between the **jejunum** and the junction between the small and large intestines.

Isotope Any one of the different forms of an element, possessing the same number of protons in the nucleus but different numbers of neutrons.

Jejunum The part of the small intestine connecting the **duodenum** to the **ileum**.

Keratin A fibrous protein in the skin, nails and hair which helps to flatten and harden the skin.

Labyrinth The inner ear – a complicated system of ducts and cavities making up the organs for hearing and balance.

Lacuna A small cavity; in **compact bone** a lacuna houses a bone cell.

Lamella/lamellae The thin bands of calcified material which are arranged in concentric fashion around a **Haversian canal**.

Leucocyte A white blood cell.

Lymph A fluid derived from blood which bathes the body's tissues before being returned to the bloodstream via the **thoracic duct**.

Lymphatic (Adj.) Relating to the lymphatic system: the network of vessels which circulate **lymph**.

Lymphocyte A variety of white blood cells vital for immunity within the body. They are present in lymph nodes, spleen, thymus gland, gut wall and bone marrow.

Lymphoid tissue Tissue associated with the immune system, responsible for the manufacture of **lymphocytes** and **antibodies**.

Lymphokine A substance such as interleukin 2, manufactured by **lymphocytes**, which affects other cells in the immune system.

Macrophage A large-sized scavenger cell found in many tissues and organs. It removes foreign bodies and bacteria from tissues and blood.

Macula A Latin word meaning a small spot or mark. The macula of the retina is an area with the **fovea** at its centre, which is specialized for acuity of vision. The macula of the inner ear transmits information to the brain about the position of the head.

Medulla The inner area of an organ or tissue situated below the **cortex**.

Medulla oblongata The uppermost end of the spinal cord, situated in the skull. It carries nerve impulses to and from the brain.

Meiosis A four-phase process of cell division, occurring prior to the formation of sperm and **ova**, whereby each new cell contains half the **chromosomes** of the original cell.

Microbe An organism which is too small to be seen by the unaided eye.

Microvillus/microvilli Tiny hairlike projections of the **epithelium** which increase its surface area, aiding in secretion and absorption.

Mitochondria A structure in a cell's **cytoplasm** associated with energy production.

Mitosis Cell division, creating two genetically identical daughter cells, as when new cells are reproduced for growth and repair.

Mucosa The moist membrane lining many of the body's tubular structures and cavities, such as the nasal and respiratory passages.

Myocardium The middle of the three layers which form the wall of the heart. It is composed of cardiac muscle.

Myofibrils Contractile filaments (shrinking or shortening) found within the **cytoplasm** of **striated muscle** cells. Bundles of these filaments make up striated muscle.

Neuroglia The special **connective tissue** of the central nervous system.

Neuromuscular synapse The minute gap at the end of a nerve fibre, across which impulses jump from one **neuron** to the next.

Neuron A specialized nerve cell which transmits electrical impulses from one part of the body to another.

Olfactory (Adj.) Relating to the sense of smell. The mucous lining of the nasal cavity contains sensory cells which are chemically stimulated. The olfactory nerve passes signals relating to smell to the brain.

Oligodendrocyte One of the cells of the **neuroglia**, which creates the myelin sheaths for **neurons** in the central nervous system.

Oocyte A cell in the ovary which after **meiosis** forms an **ovum**.

Optic disk The beginning of the optic nerve, where nerve fibres leave the eyeball.

Osteoblast A cell which is responsible for the formation of bone.

Osteoclast A cell with more than one **nucleus** which functions to reabsorb calcified bone.

Osteocyte A bone cell which has ceased to function and has become embedded in the bone matrix.

Oviduct (or **Fallopian tube**) Either of the two tubes that conduct egg cells or **ova** from the ovary to the uterus.

Ovum/ova A mature female sex cell.

Pacinian corpuscles The touch sensors within the skin, consisting of sensory nerve endings embedded in layers of membrane.

Palatine The L-shaped bones of the face that contribute to the orbits, the nasal cavity and the hard palate.

Papilla/papillae Small projections within the body, notably those found on the tongue. There are several different types of papillae on the tongue which are associated with the taste buds.

Pathogen A parasitic micro-organism, such as a virus or bacterium, which creates disease.

Phagocyte A cell which digests bacteria, cell debris and foreign substances.

Plasma The fluid in which blood cells are suspended.

Pneumocytes A type of cell which lines the walls of air sacs in the lungs, thus separating them.

Purkinje cells Nerve cells found in great numbers in the **cortex** of the **cerebellum**.

Radio-isotope An isotope of an element that emits radiation (alpha, beta, or gamma) during its decay into another element.

Renal (Adj.) Relating to the kidneys.

Rhodopsin A purple pigment found in the retina of the eye. Consisting of vitamin A and protein, it is essential for 'night' vision. Light bleaches the pigment, creating nervous activity in the rods.

Ribonucleic acid (RNA) A nucleic acid which is found in the **nucleus** and **cytoplasm** of cells. It synthesizes protein. In some viruses RNA is the genetic material.

Rods Light-sensitive cells in the retina of the eye. There are about 130 million rods in the eye. They function in poor light and switch off in bright light.

Ruga/rugae A fold in the mucous membrane lining the stomach. The term may be used generally to refer to folds and creases.

Sebaceous glands Glands in the skin, opening into hair **follicles**, which secrete **sebum**.

Sebum An oily substance secreted by the **sebaceous glands** to cover the skin, thus slowing evaporation of water and providing protection against bacteria.

Serous (Adj.) Relating to **serum**.

Serum The fluid left after the blood has clotted. It therefore differs from **plasma** in not containing the factors responsible for coagulation.

Stereocilia Rows of hairs in the inner ear through which sound waves are turned into the electrical impulses received by the brain.

Streptococcus Spherical bacteria which occur in chains. Many types have the ability to destroy red blood cells. They are responsible for many kinds of infections.

Striated muscle Tissue composed of multinucleate (more than one nucleus) fibres. Responsible for the movement of bones and **voluntary muscle**.

Subclavian artery Either of two arteries supplying blood to the neck and arms.

Thallium 201 A **radio-isotope** used during a gamma-camera scan of blood flow through the heart muscle.

Thoracic duct One of two main ducts of the **lymphatic** system. It receives **lymph** from the legs, lower abdomen, left thorax, left side of the head and left arm and drains into the left of the two innominate (unnamed) veins which occur one at each side of the neck.

Thoracic vertebrae The twelve bones of the spine to which the ribs are attached.

Thrombus A blood clot.

Thymus A bi-lobed organ located in the root of the neck, filled with white blood cells associated with **antibody** protection.

Trabeculae A band of tissue passing from the outer part of an organ to its interior, thus dividing it into separate chambers.

Trachea The windpipe from the larynx to the main **bronchi**.

Ureters The two tubes which carry urine from the kidneys to the bladder.

Urethra The tube carrying urine from the bladder to the body exterior.

Vas deferens The two tubes or ducts which carry spermatozoa from the **epididymis** to the **urethra** on ejaculation.

Ventricle Either of the two lower, blood-pumping chambers of the heart.

Vesical (Adj.) Relating to any bladder, especially the urinary bladder.

Vesicle A small bladder, especially when filled with fluid.

Villus/villi A short finger-like process which projects from certain membranous surfaces such as the small intestine.

Viscera The organs of the body located within its cavities.

Voluntary muscle (also skeletal muscle) Muscle under voluntary control.

Zona pellucida The thick membrane, penetrated by a spermatozoon at fertilization, which develops around the **oocyte**.

SOURCES OF IMAGES

ACKNOWLEDGMENTS

I wish to thank the staff of the Wellcome Institute for the History of Medicine and the Wellcome Centre for Medical Science, London, for their encouragement, support and active involvement in this project. In particular, I owe a debt of gratitude to Ken Arnold, Exhibitions Officer of the Wellcome Institute, who recognized the value of organizing a complementary exhibition, and whose previous exhibitions and catalogues (particularly *Picturing the Body: Five Centuries of Medical Images*, 1994) were immensely helpful in providing me with an understanding of the historical underpinnings of the imagery and imaging systems in question; Dr Laurence Smaje, Director of the Wellcome Centre, who embraced another opportunity of illuminating the ties that bind art and science; Steve Pemberton, Manager of the Wellcome Centre, who put his resources at our disposal; and Catherine Draycott, Manager of the Wellcome Centre Medical Photographic Library, who was, with Michele Minto, most generous in finding and providing transparencies of the historical material in the book.

The staff of the Science Photo Library were also most helpful in providing the imagery and corresponding information contained here. In particular, I must thank Brandon Broll, Scientific Consultant, who patiently explained the bewildering imaging techniques and their functions and who set up conversations with image makers; Julia Kamlish, whose knowledge of the library's holdings led me to many extraordinary images; Rosemary Taylor, who provided valuable information; and Andy Clarke, who coordinated the project from the library's point of view.

I must also express gratitude to the scientific image makers whose complex works grace the pages of this book, especially Dr Jeremy Burgess, Professor Pietro Motta, Dr Nancy Kedersha and Manfred Kage, for the information they provided concerning their motives and working methods.

The book *Microcosmos* by Jeremy Burgess *et al.*, published in 1987 by Cambridge University Press, has proved invaluable and is recommended reading for anyone who wants to know more about the technical procedures.

The artists who have kindly allowed me to use their work as motifs for each chapter also deserve a vote of thanks: Helen Chadwick, Andrea Owen and Robert Davies, of London; Lynn Davis of New York, Rémy Fenzy of Paris, Jo Brunenberg of Weert (Holland) and Javier Vallhonrat of Madrid.

Finally, my heartfelt thanks to my wife, Clare, for her contribution: a useful glossary in terms a layman such as myself can understand.

Publisher's acknowledgment
The publishers would like to thank Dr D.C. Sprigings for reading and advising on the captions and glossary.

INDEX